IMAGES
*of America*

# RUSTON

For Kim and Bill,
    Ruston and Lincoln Parish
have been home to us Beltons for
a long, long time. We thought you'd
enjoy "traveling" back in time with
us through these photos.
               Love,
               Mom & Dad

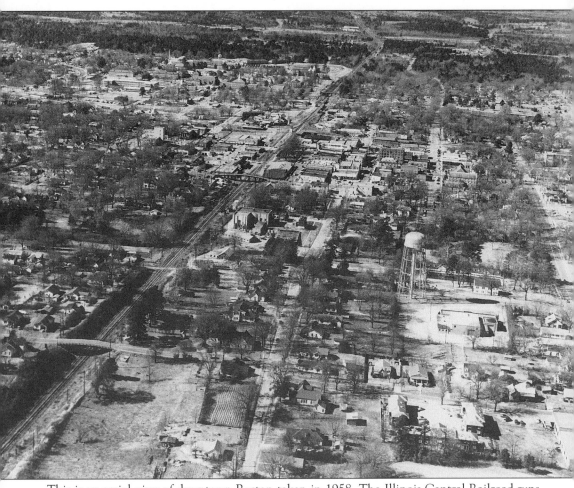

This is an aerial view of downtown Ruston taken in 1958. The Illinois Central Railroad runs from center top (west) to bottom left (east). (Woodward.)

IMAGES
*of America*

# RUSTON

Barbara Pfister Dailey and Pamela J. Pfister

ARCADIA

Published by Arcadia Publishing,
an imprint of Tempus Publishing, Inc.
2 Cumberland Street
Charleston, SC 29401

Printed in Great Britain.

Library of Congress Catalog Card Number: 00-104871

For all general information contact Arcadia Publishing at:
Telephone 843-853-2070
Fax 843-853-0044
E-Mail sales@arcadiapublishing.com

For customer service and orders:
Toll-Free 1-888-313-2665

Visit us on the internet at http://www.arcadiapublishing.com

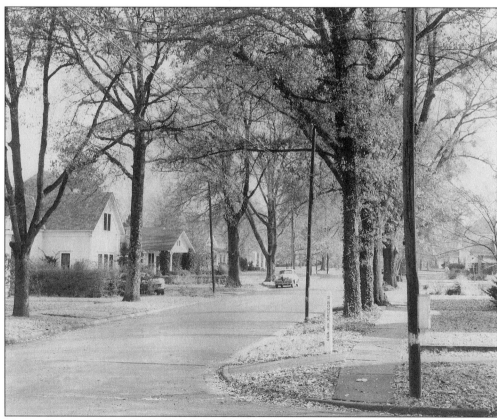

This is the intersection of South Bonner Street and Arizona Avenue in 1954. The white street marker can be seen on the corner. These were replaced by traditional street signs in the late 1960s. (Woodward.)

*Martha Sue, Aunt Alberta (Bert) and Uncle Carl lived on East Arizona during the late 1940's.*

# CONTENTS

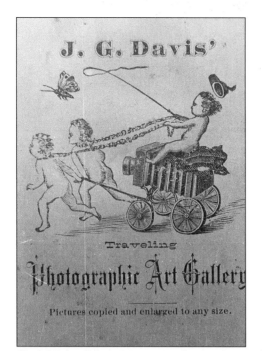

(*Right*) John Green Davis started out as a traveling photographer and produced portraits in the form of carte-de-visites, cabinet cards, and tintypes. Elaborate logos such as this one were printed on the back of these cards. (Davis.) (*Left*) Pictured here is John Green Davis Sr. in 1938. (Davis.)

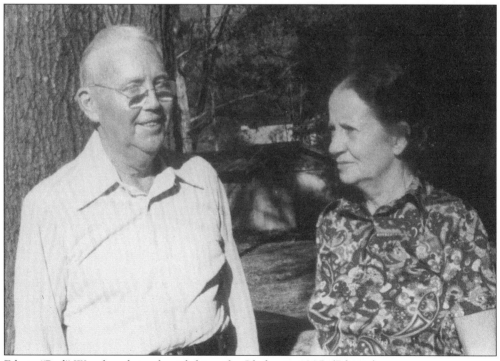

Edwin "Red" Woodward stands with his wife, Gladys, in 1985. (Pfister.)

# INTRODUCTION

Ruston was founded in 1884. The Vicksburg, Shreveport & Pacific Railroad was putting a line across north Louisiana, and railroad officials wanted the new tracks to be a straight line across the state from west to east. Thus, the railroad was built 10 miles south of the nearest town, Vienna, on farmland donated to the railroad by Robert Russ. When a town sprang up around the railroad, it was known as Russ Town, later evolving into Ruston. Many people who lived in Vienna moved to Russ Town, brought their businesses to be near the railroad, and literally moved their houses. The oldest buildings in Ruston started out in Vienna. When the city was layed out, all east-west streets were named for states, and the north-south streets were named after towns in Louisiana. Two of the main streets, Vienna and Trenton, were named after the towns where most of the people had lived. Trenton was the old name for West Monroe.

Colonel Louis Fuller Marbury and his family came to Russ Town when it was first established. Colonel Marbury was one of the first druggists in town, and he also was an amateur photographer who loved to take pictures of events around town. He climbed onto the tops of buildings carrying the large tripod and camera with him to get some of his most unusual shots, such as the balloon ascension in Railroad Park in 1896. The Marbury drugstore sold many items such as books and school supplies, and it was the first to sell photographic equipment in Ruston. Colonel Marbury was an agent for Eastman Kodak Land cameras and film. The only thing that made Colonel Marbury an amateur photographer was that he did not do it full time. In the 1930s the local library exhibited some of Marbury's photographs complete with captions. Ruston photographer John Davis got permission to take pictures of them, thus saving some of Marbury's photographs for future generations.

John Green Davis started his photographic studio in Ruston in 1899 and operated it until his death in March of 1940, three days before his 87th birthday. Davis spent his early years as a photographer living and working from a covered wagon. He would go from town to town setting up a photographic tent. He mainly did portraits in the form of carte-de-visites, tinytypes, or cabinet cards, which were small 3 x 2 prints on heavy paper similar to the business cards of today. It was common for the photographers to print an elaborate logo on the back of these cards. An example of one of Mr. Davis's cards is pictured in the front of the introduction (page 6).

From 1904 to 1938, most of Davis's work was with the Louisiana Tech yearbook, *Lagniappe*. With the increase in popularity of photography, Davis's business became very successful. After his death, his wife, Ava, and his son, John Jr., operated the studio. Ava Davis died in 1957, and four years later John Jr. died. After John Jr.'s death, the family auctioned off the studio, which was purchased by Ruston photographer Edwin "Red" Woodward. Woodward kept all of Davis's photographic paraphernalia and added his own work to the collection. Red had worked for the post office for years and only did photography on the side. After he bought the Davis studio, he started working full time as a photographer before retiring in 1972.

In 1952, a young Air Force photographer named Bob J. Pfister came to town. He was dating a Louisiana Tech student named Bettie Anne Bauguss, whom he eventually married. Louisiana Tech requested that he photograph various activities of the university. During this time Bob became good friends with Woodward and his wife. From 1956 until 1981, the Pfisters lived in Tucson, Arizona, and returned to Ruston when Bob retired.

When Woodward died in 1986, he left everything in his studio to Pfister. However, the exciting news came later when Mrs. Woodward called to say that she had found some boxes of photo equipment in her shed. The boxes had rotted, but Pfister was able to salvage hundreds of negatives. A lot of them were made of glass, and it took weeks to sort through them. He was quoted in the *Ruston Daily Leader* (6-30-89) as saying the following: "As we looked through those negatives, I knew right away that I had the pictorial history of Ruston right here in my hands." Pfister started thinking about putting the pictures together into a pictorial book about Ruston's history, but before he could start on his dream, he had a major stroke which left him confined to a wheelchair.

Now, almost ten years after his stroke, we wanted to complete what our father had started. Growing up in the Pfister household meant our school vacations were spent traveling backroads and photographing all we saw. Our father would sometimes get us from school to take us to some special event he was photographing. Some of our happiest memories are of going with our father when he took pictures and helping him in the darkroom afterwards.

Pam still prints pictures for people from our father's collection of old negatives, using some of the equipment from the Davis and Woodward studios. We got together and decided that we would like to have our dad's dream become a reality, for he always felt that the past needed to be saved. Together we can make his dream come true.

Barbara Pfister Dailey
Pamela J. Pfister

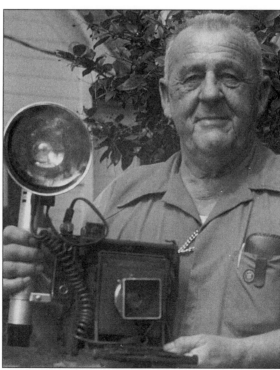

Bob J. "Sarge" Pfister poses with a speed graphic in 1990. (Pfister.)

# *One*
# RAILROAD CROSSING

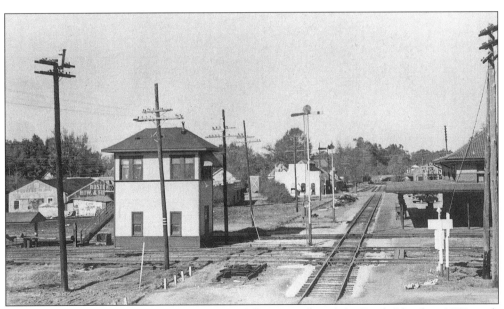

Pictured is the crossing of the Illinois Central (horizontal) and the Rock Island in 1953, with the train tower overlooking the lines. The Rock Island line was torn out in 1987, and the Illinois Central has become the Kansas City Southern. (Pfister.)

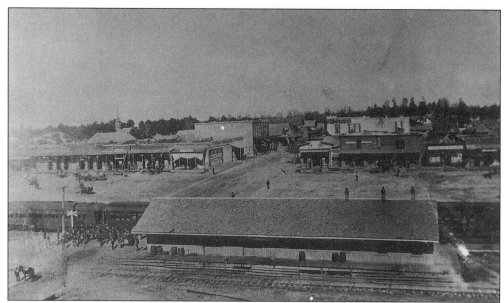

Here we see a passenger train stopped in Ruston around 1900. The gentleman holding his horse has been identified as P. Colvin. (Marbury.)

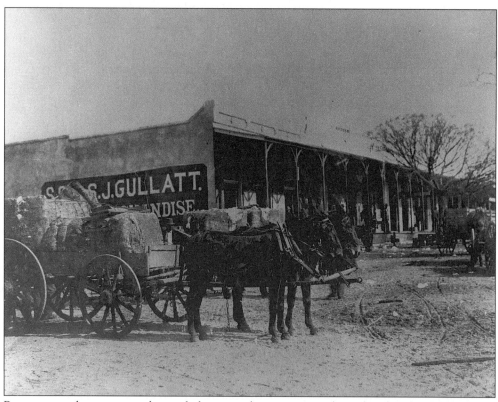

Ruston was a busy town with people bringing their cotton to the railroad and patronizing the local merchants. (Davis.)

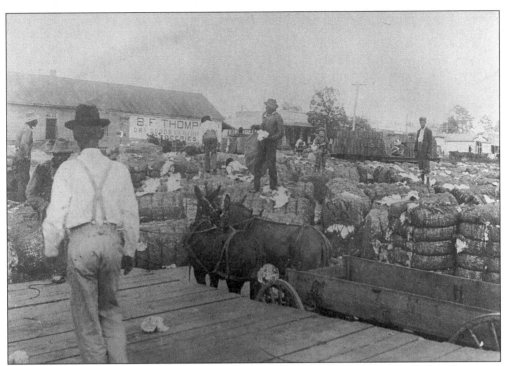

Cotton was loaded at the Railroad Warehouse in 1905. This big field was packed with wagons from all over the northern part of the state during cotton-picking time. Twenty to thirty thousand bales were being shipped annually out of Ruston by this time. (Davis.)

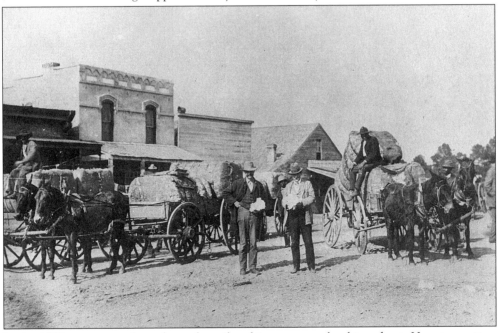

In the 1890s cotton was brought to the railroad in wagons to be shipped out. Here two cotton farmers are comparing their cotton. They are standing on Trenton Street in front of where Rogers Furniture store is located today. (Marbury.)

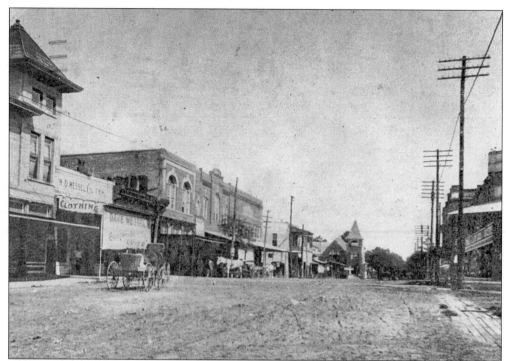

Muddy streets and wooden sidewalks describe Ruston's main street (North Trenton, c. 1895). Horses and buggies are the only traffic. The bell tower of Trinity Methodist Church is very noticeable at the end of the street. (Marbury.)

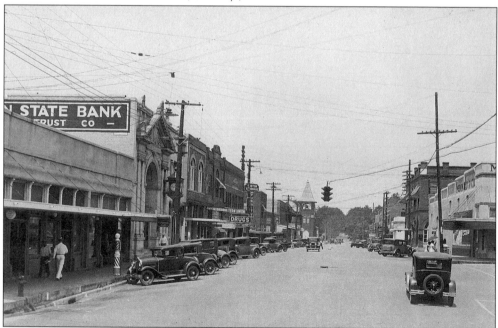

Now we have a streetlight! In this late-1920s view of Trenton Street looking north, McDonalds store is on the right and the bell tower of Trinity Methodist can still be seen at the end of the street. (Davis.)

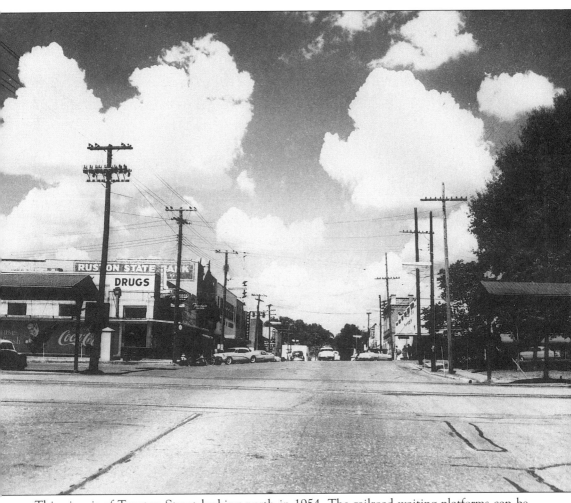

This view is of Trenton Street looking north in 1954. The railroad waiting platforms can be seen on either side of the street. Trenton Street gets its name from Trenton, Louisiana, the old name for West Monroe. (Woodward.)

We got our first television in 1954. Kim early on loved watching "Upper Gofrey" Arthur Godfrey.

We bought TV, and a 3 piece oak bedroom suit - to be paid monthly for ever so long!

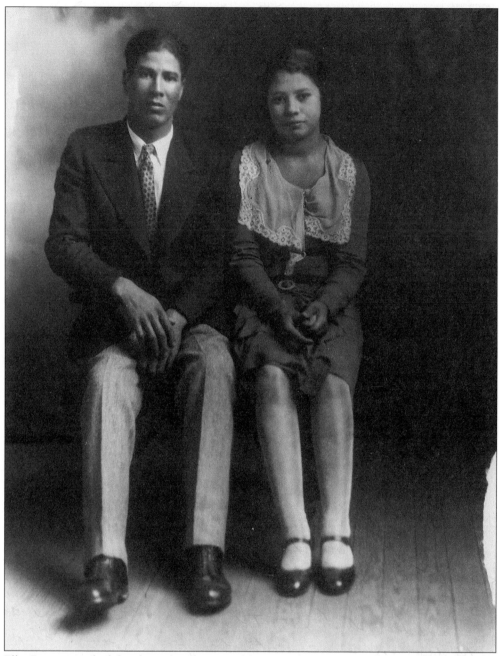

Ellis Bonner worked for the railroad. He and his wife, both pictured here on November 16, 1929, were part of the Bonner community in south Ruston, which is where Bonner Street got its name. (Davis.)

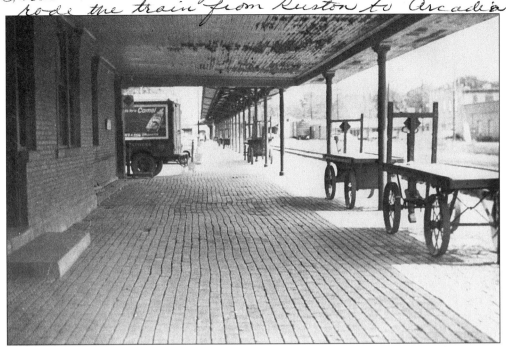

The railroad station in Ruston was usually a bustling place. Here the photographer shows the quiet time between the trains. (Davis.)

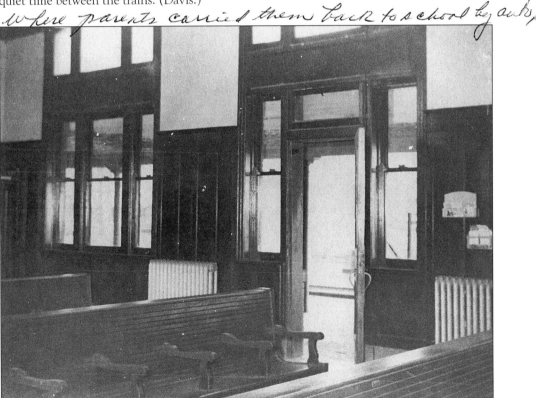

The railroad station waiting room sits quiet and deserted—silent until the next train. (Davis.)

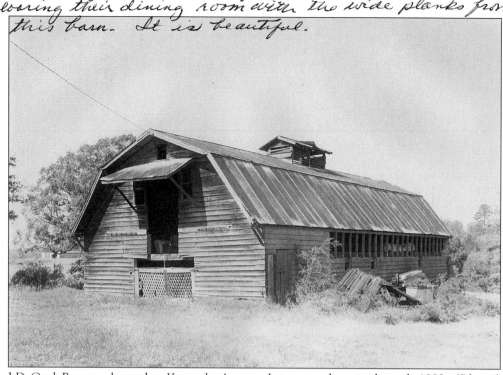

J.D. Cook Barn was located on Kentucky Avenue. It was torn down in the early 1990s. (Pfister.)

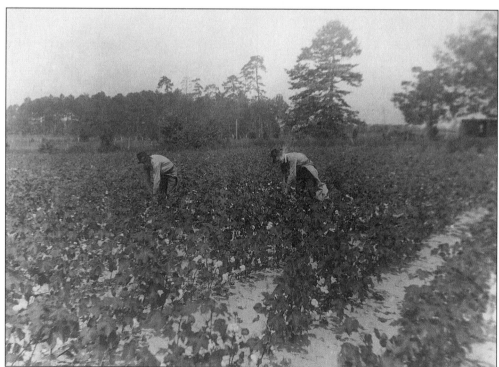

Cotton was one of the major crops shipped out of Ruston by railroad. Here we see two farm workers picking cotton in 1928. (Davis.)

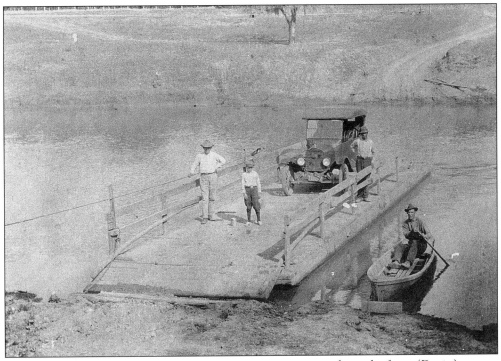

In 1920, the only way to get your car or wagon across some ponds was by ferry. (Davis.)

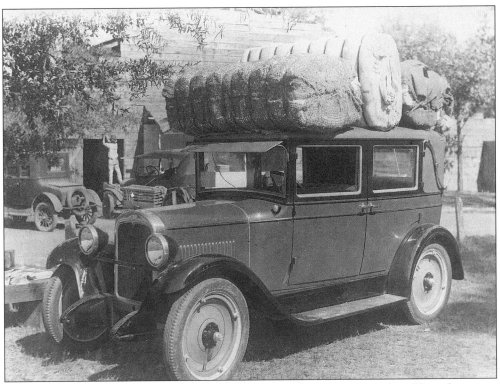

This picture, c. 1926, shows a very inventive way to get the cotton to market. (Davis.)

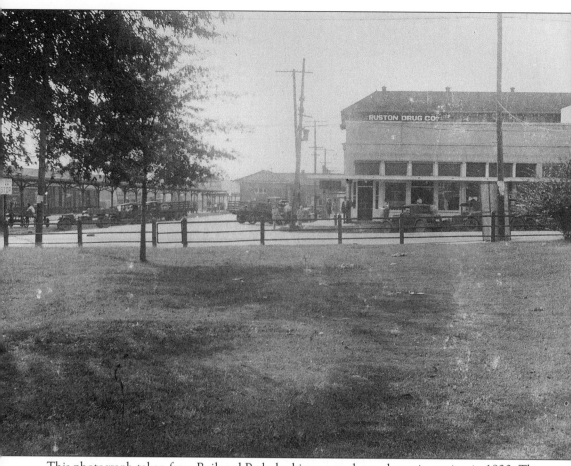

This photograph taken from Railroad Park, looking west, shows the train station in 1920. The town centered and grew around the railroad. (Davis.)

# Two

# ALONG HIGHWAY 80

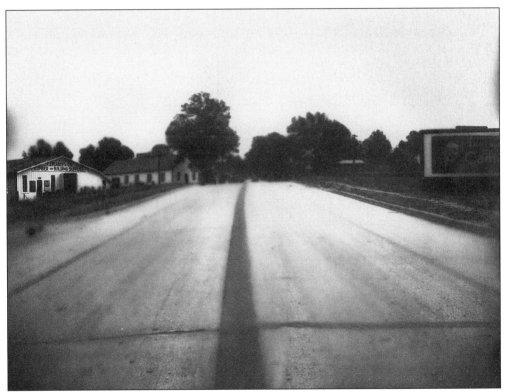

This is California Avenue, also Highway 80, in 1937. Pearce Lumber is still in the same place to the left, but now many more businesses line the street. This was one of the main roads through Ruston. (Davis.)

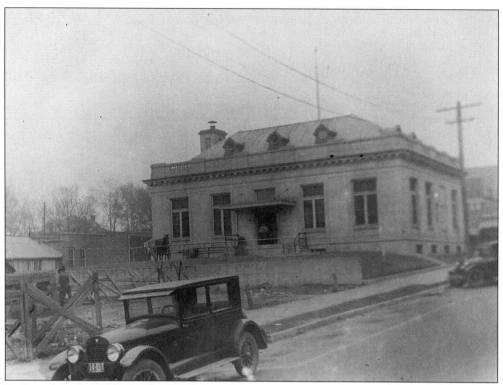

In this picture of Old Lincoln Parish Post Office, *c.* 1915, you can see the stables provided for the mailmen's horses. When the post office began to provide trucks, the stable was cleared. The T.L. James building now stands in its place., while the old post office is now the Federal Building. (Davis.)

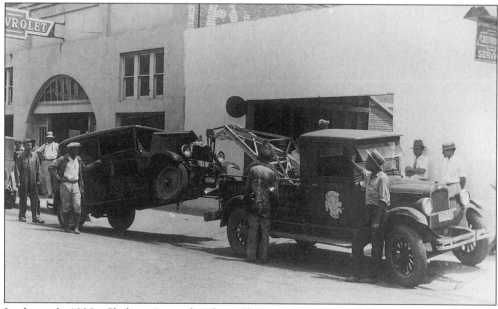

In the early 1930s, Shelton A wrecker from Chevrolet Company of Ruston tows a vehicle to Feazel Motor Company. Feazel Motor Company began in 1912. (Davis.)

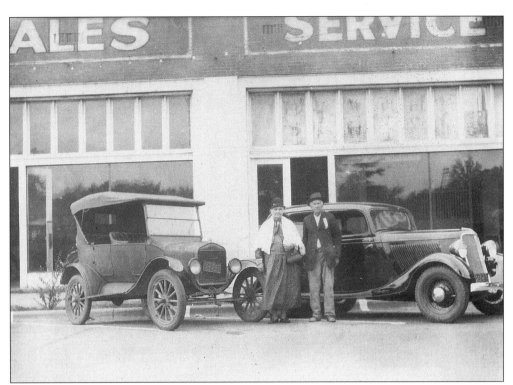

Marian and Flora Davis trade in their old vehicle for a new one in 1933 at Feazel Motor Company. (Davis.)

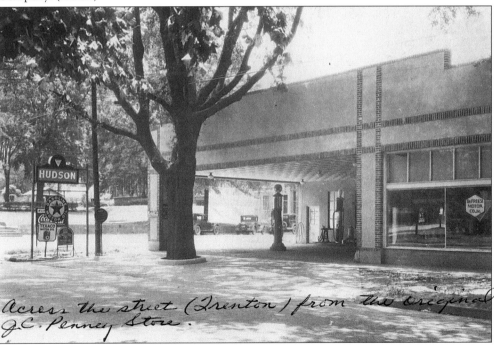

*Acress the street (Trenton) from the original J.C. Penney Store.*

In the l930s, Defreese Motor Co. and Jessie Harris Gas Station were on the corner of Highway 80 in downtown Ruston. (Davis.) *Owner, Cleve Defreese, was the father of Joyce Defreese Stephenson, Beverly Canterbury's mom. and a Belton relative. Pa & Prentis Belton worked for Cleve as did Reba Hughes (friends of ours from Cook Baptist Church.*

21

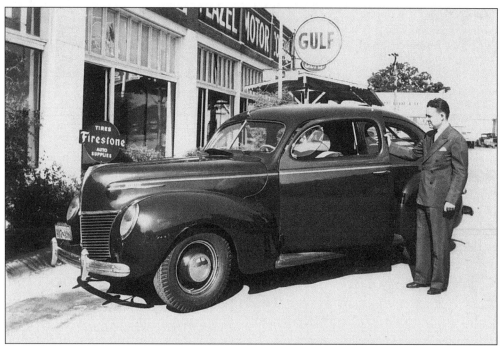

District Attorney Truett Scarborugh stands outside Feazel Motor Company in 1938. (Davis.)

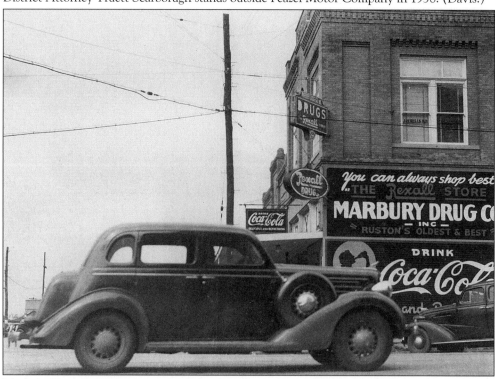

Marbury Drug Company was one of the first drugstores in Ruston, with Colonel Louis Fuller Marbury being the owner and operator. Here on the side of the building, they advertise themselves as "Ruston's Oldest & Best." (Davis.)

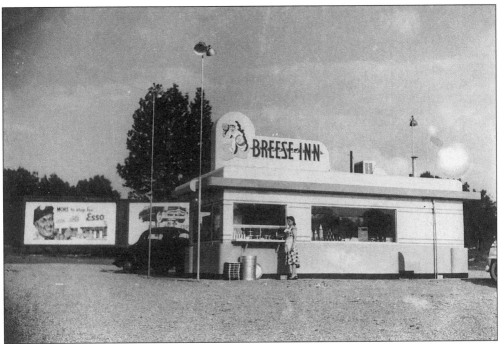

This *c.* 1940s picture shows Breeze Inn Drive Inn on Highway 80 just as you leave town going toward Choudrant. Southern Classic Chicken is now in this location. (Davis.)

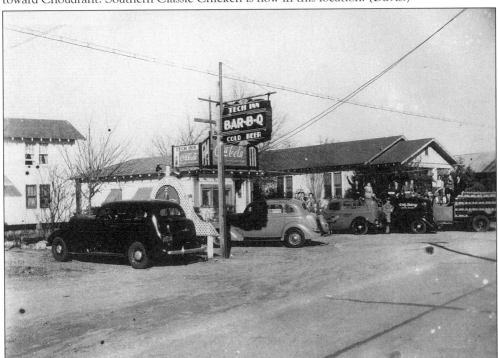

Tech Inn Bar-B-Q, affectionately known as "Greasy Bill's," was a popular place for Tech students during the 1940s and 1950s. It was just off campus, across the street from Bogard Hall. (Davis.) *You could have lunch at Greasy Bill's for a quarter: Hamburger 15¢, coke 5¢ and potato chips 5¢. Only problem, Tech students didn't always have 25¢ in 1951! Bill used the "honor" system.—You just put your money on the counter.*

23

West California Avenue in the 1950s cut through fields with a few buildings along the way. The steeple from Keeny Hall at Louisiana Tech can be seen topping the trees in the center. (Woodward.)

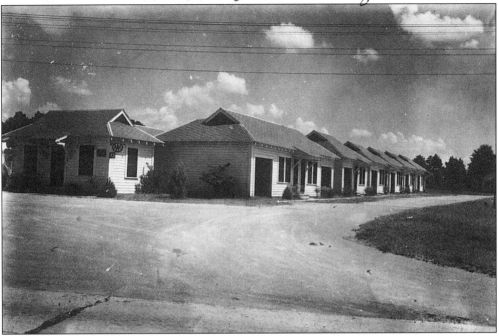

Now a part of China Inn Motel, Mr. Maxwell's Cabins are seen here on August 8, 1941, on Highway 80. (Davis.)

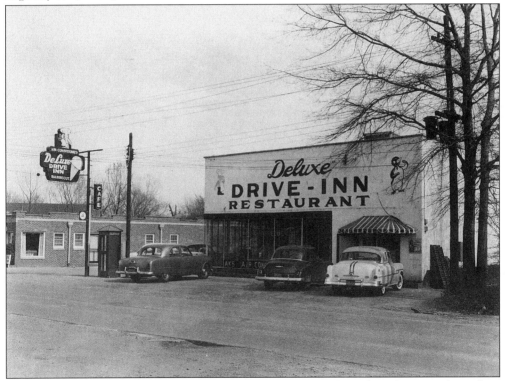

Deluxe Drive-Inn in 1953 was known for its chicken fried steaks. It later became The Deluxe Marina. (Pfister.)

Barbara Ann - Anderson loved being snowbound with us. Lil threw everything in a pot, called it goo-lash and fed all our friends. We had loads of fun playing in the snow.

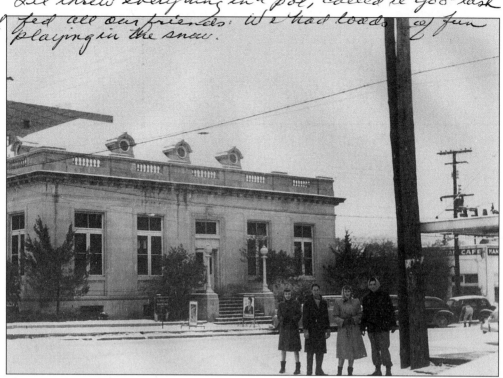

The Manhattan Cafe, later known as the P.O. Cafe, can be seen on the right along with the post office in the 1949 snowstorm. (Woodward.)

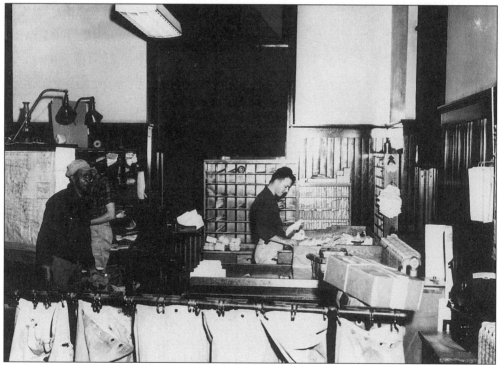

Ruston's post office employees sort mail during the Christmas rush in 1953. (Woodward.)

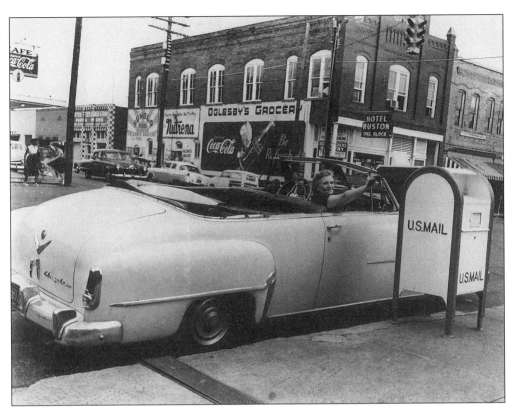

This picture was taken in 1955 when Mrs. Lillian T. Pearce became the first postmistress of Ruston. She is shown here mailing a letter at the postal box in front of the post office. (Woodward.)

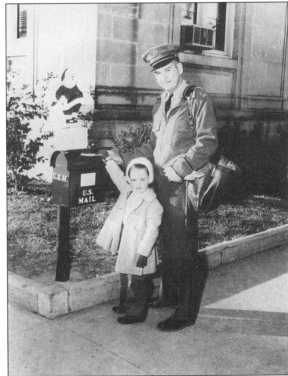

A postman and his daughter mail a letter to Santa on November 28, 1956. (Woodward.)

*This is Francis Stephenson with Beverly, now Mrs. Mike Canterbury.*

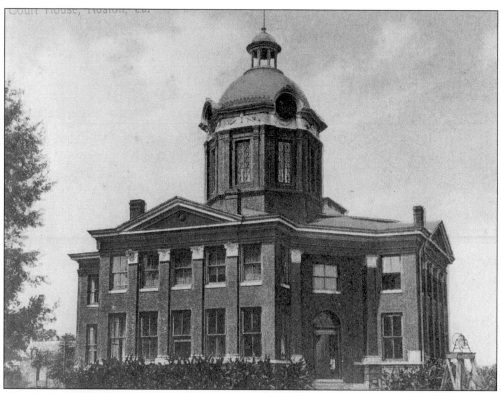

This photograph of the "new" courthouse was taken in 1900. It was used in a series of postcards of Ruston. (Davis.)

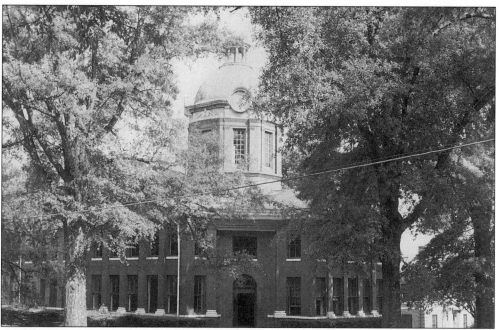

This picture of the Lincoln Parish Courthouse was taken in the summer of 1949 just before it was torn down. (Woodward.)

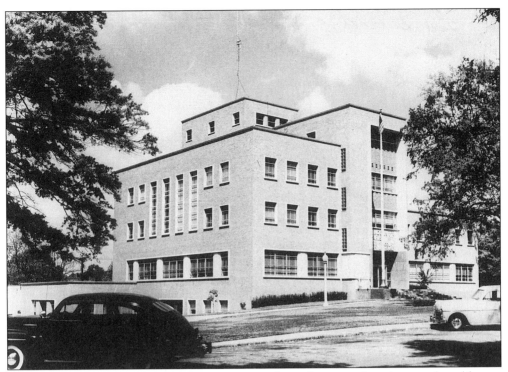

In 1950, the "new" courthouse was constructed in the same location as the old one. (Woodward.)

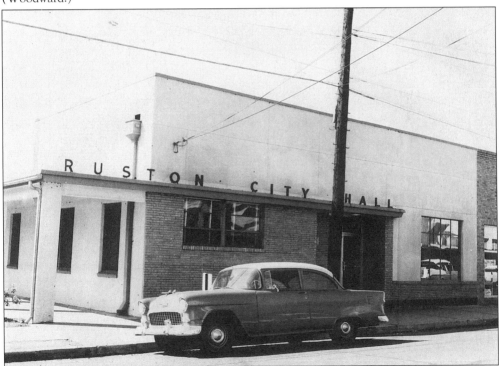

Ruston City Hall in the 1950s was on Mississippi Avenue across from the fire station. (Pfister.)

Our S.S. Superintendent at Temple, L.G. Hussey worked at City Hall as did Harmolean Rowe; remember her — she was a friend of all of Keri's bunch of friends.

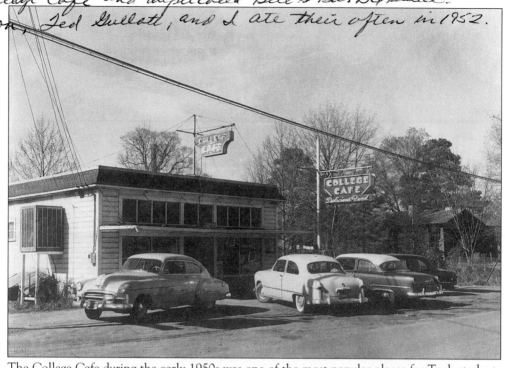

The College Cafe during the early 1950s was one of the most popular places for Tech students to go out for supper. It was located just off campus on California Avenue. (Pfister.)

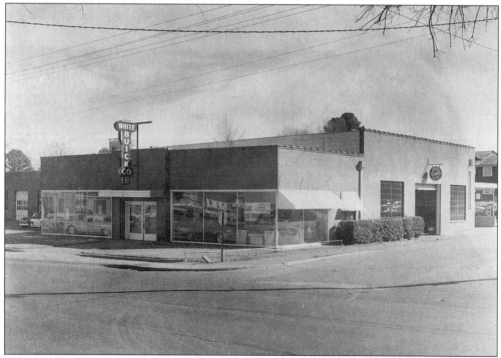

One of Ruston's car dealerships, White Buick Company is shown here in the 1950s. (Woodward.)

# *Three*
# BEFORE THE MALLS

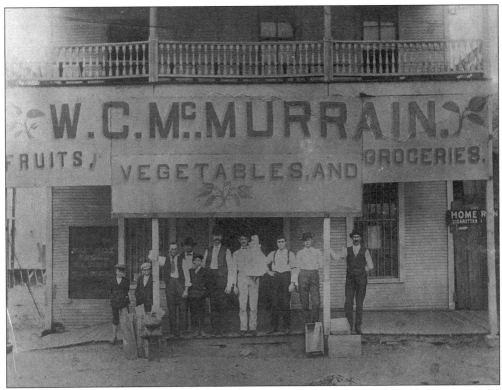

McMurrains Grocery was located on the corner of West Mississippi and North Trenton. The men identified, from left to right, are as follows: Sam Walker, Jim Harris, O.W. Perkins, W.C. McMurrain, two unidentified men, and George Reynolds. The only child identified, the little boy on the extreme left, is Rene Morgan. (Marbury.)

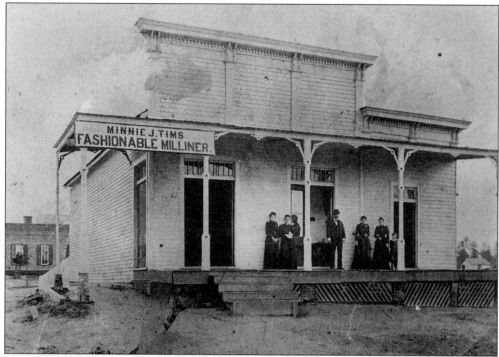

Seen here in the late nineteenth century, Miss Minnie J. Tims Fashionable Milliner was built in the 1890s. (Marbury.)

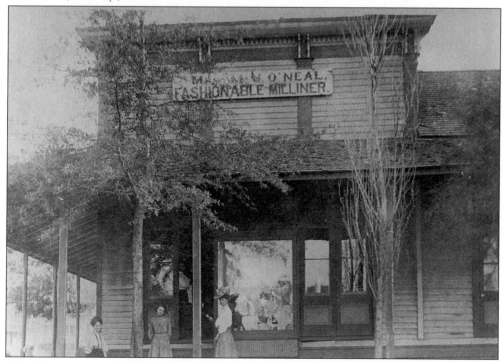

Miss Tims, now married, has changed the store name to Mrs. Minnie O'Neal Fashionable Milliner. Several years have passed, and trees have grown up around the building. (Marbury.)

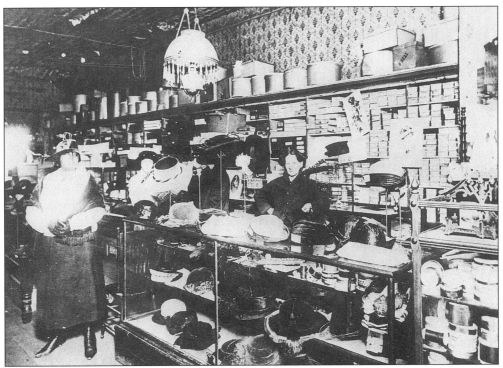

This is the interior of Miss Tims Fashionable Milliner Store. (Marbury.)

The employees of McDonalds store are ready to serve their customers in the 1920s. (Davis.)

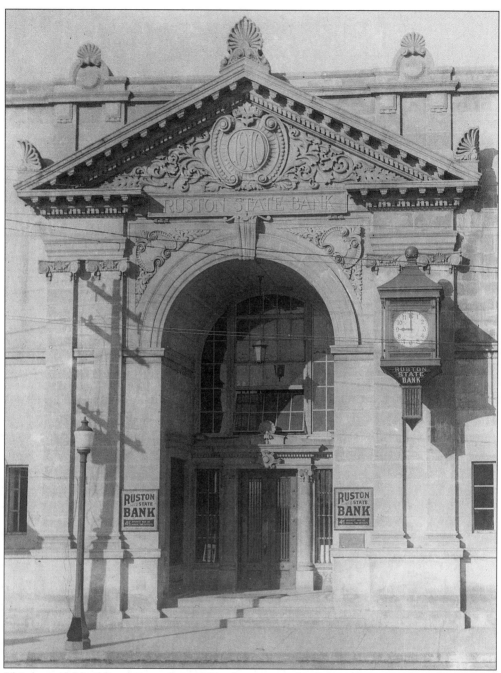

This beautiful building, pictured in 1920 when it was the Ruston State Bank, still stands on North Trenton, though it is no longer used as a bank. Notice the 1910 medallion in the pediment. (Davis.)

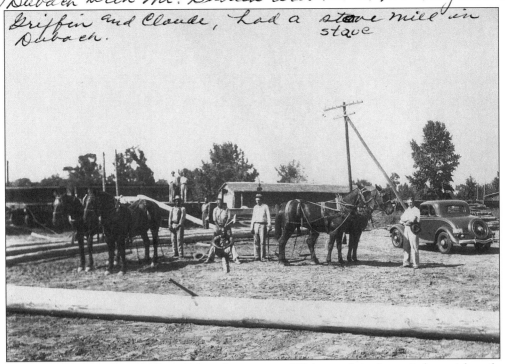

The work crew of Mr. J.E. Allen's Piling Company in 1934 moved the large timbers with mule teams. (Davis.)

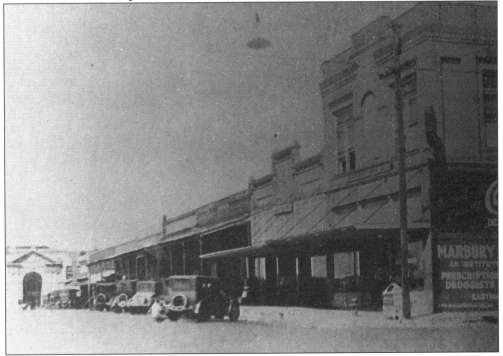

In the 1920s, cars parked along the busy street of Park Avenue. The Ruston State Bank building on the left and the Marbury Drug building on the right are still there today. (Davis.)

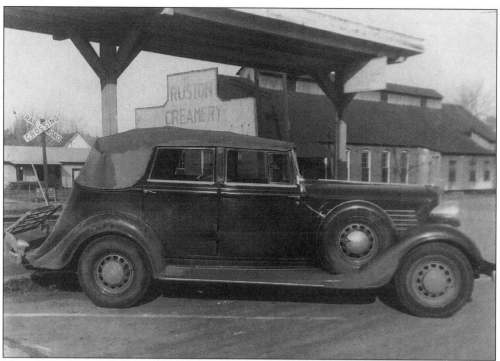

This photo taken in 1935 by Davis's studio shows a Chrysler parked in front of the old Ruston Creamery. The Ruston Creamery was started in 1915 by R.B. Knott to develop the dairy industry in Lincoln Parish after the bottom dropped out of the cotton market. (Davis.)

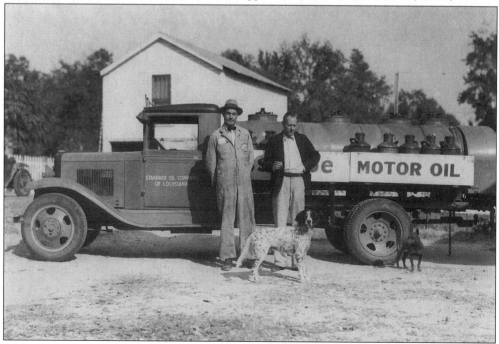

Two workers from the Standard Oil Company of Louisiana are shown with their delivery truck in the 1930s. Their two dogs decided to get into the picture, too. (Davis.)

Ruston Hardware decks their halls for Christmas in December 1938. (Davis.)

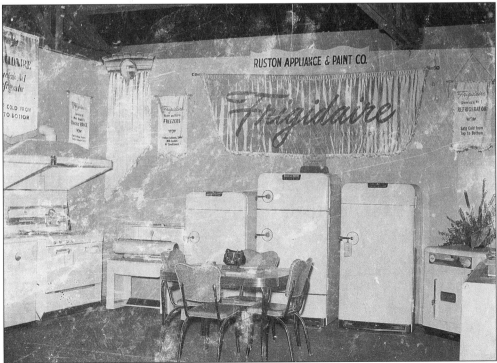

A store display of Frigidaire appliances is shown here at the Ruston Appliance & Paint Company. (Davis.) *This store was located where Lewis' Stag Shop is today and was owned by Thurman Holstead and Harold "Bud" Trussell (husband of Bobbie Belton Don's 2nd cousin, Van Belton's sister) Bud was "Aunt Ivy Nobles Trussell's son)*

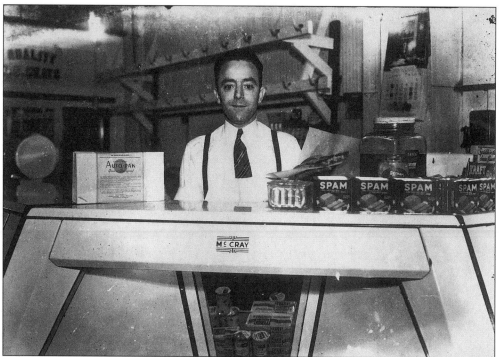

Spam, still a nationally known product, is being introduced here at the Piggly-Wiggly in 1935. Spam was used during World War II for soldiers' rations because it could travel well. (Davis.)

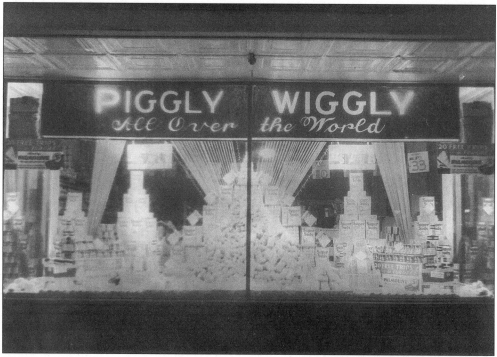

Window displays have always been eye-catching. Here the Piggly-Wiggly centers on food from places "All Over the World." (Davis.)

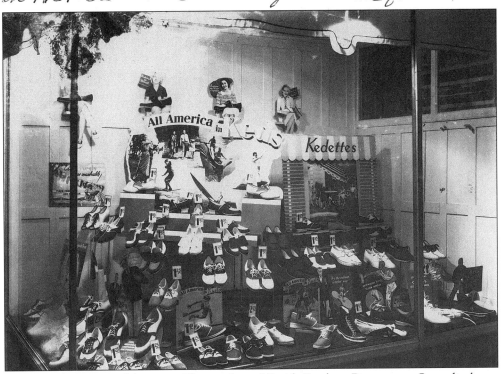

Keds have been around for years. The window of Smith Brothers Department Store displays a saying "All America in Keds." In this 1938 photograph, the most expensive pair we can see is front center for $2.25. (Davis.)

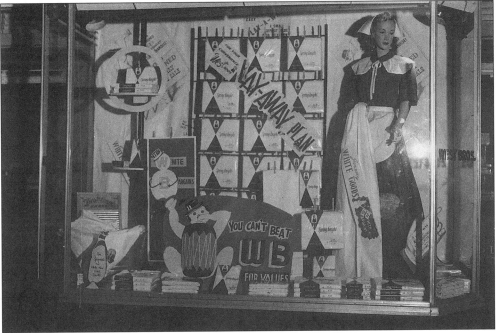

"White Sales" and "Lay-away plans" have been around for years, as proven by this West Brothers Department Store window in 1940. (Davis.)

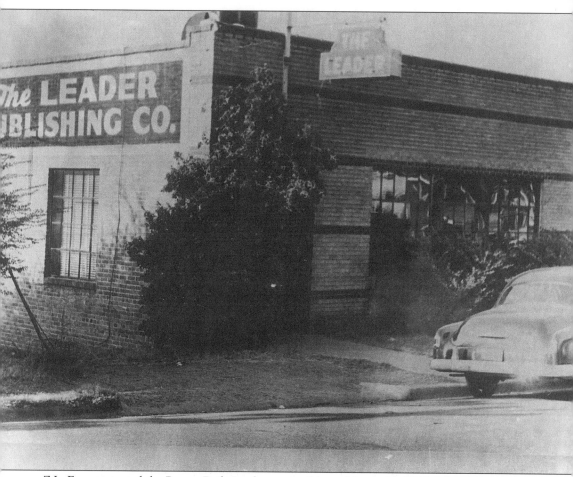

Z.L. Everett started the *Ruston Daily Leader* as a weekly on March 16, 1894. It became a daily in the 1930s when Clarence Faulk became the publisher. Here are the offices of the *Ruston Daily Leader*, located on Mississippi Avenue in 1952. The building burned in 1967. (Davis.)

Your great grandfather (John W. Allen, Sr.) was killed at his sawmill at Shiloh (Between Bernice and Farmerville) and the obituary appeared in the old Ruston Sentinel.

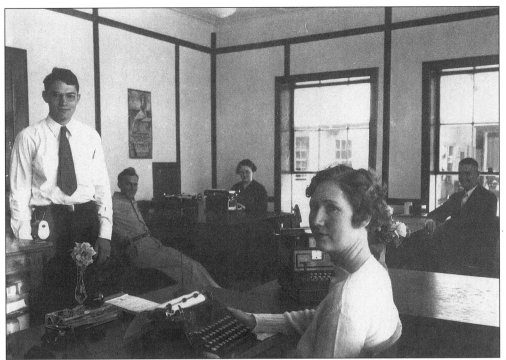

Seen here in 1937, the staff members of the *Ruston Daily Leader* in 1937 are listed, from left to right, as follows: Clarence Faulk (publisher); Milton Kelly (editor); Dorothy Lomax (woman's news); Mrs. Eunice Stuckey; and Mr. Worthing (ads and sales). (Davis.)

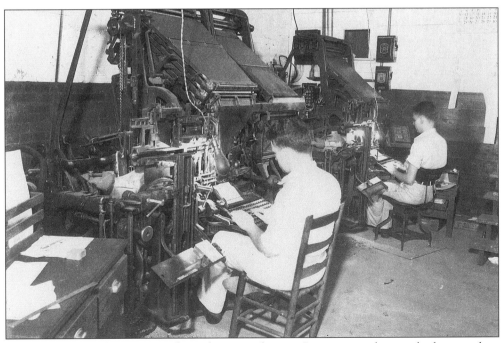

Two employees of the *Ruston Daily Leader* are working on Linotype machines, which use molten lead to set type. (Davis.)

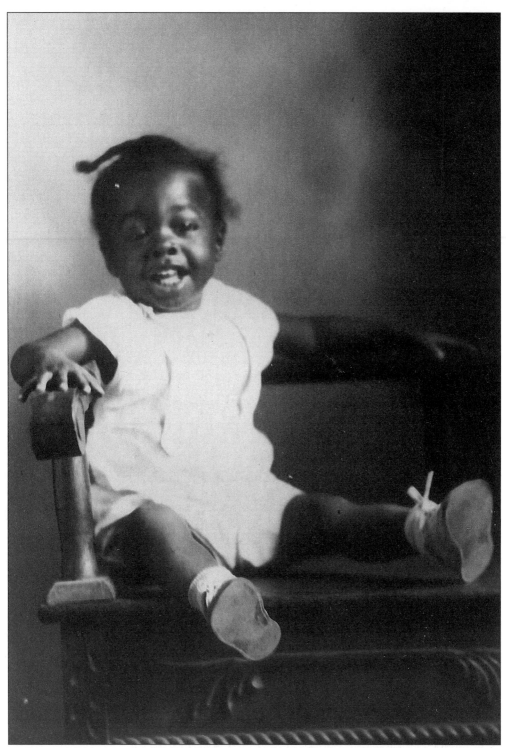

Willie and Ethel Rhee Slaton's baby had fun having her picture made. This portrait is typical of the Davis studio. Many Ruston children sat in this chair to have their portraits taken. (Davis.)

During the early part of the twentieth century, copy machines were in the future, and if you wanted a copy of something, you took it to your local photographer. Here Carnahan Buick Co. had a copy made for their records of a letter they had received. (Davis.)

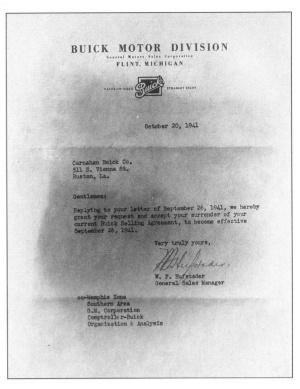

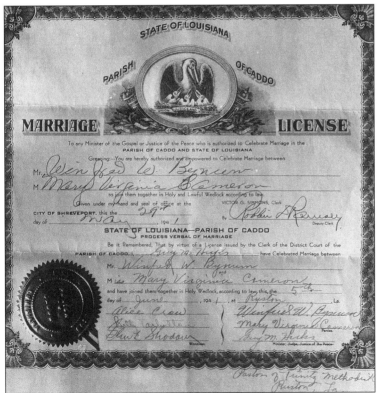

Just like today, many different items were photocopied. Here we have the Marriage License of Winfred W. Bynum and Mary Virginia Cameron, who were married on May 29, 1941. At the bottom right-hand corner, we can see that the pastor was from the Trinity Methodist Church in Ruston. (Davis.)

43

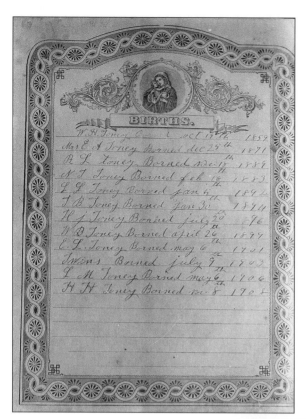

This photocopy is from the Toney family Bible. It shows the births in the family from 1859 to 1908. (Davis.)

Mr. Davis was taking some advertising photographs at Mr. Hubbards Woodworks in 1936 when the camera became part of the picture. (Davis.)

In the late 1930s, Dr. Marvin Green, pictured here, started the Green Clinic along with his brother, Dr. Felton Green. (Davis.)

This is the same Dr. Green that Lil had me see for my pre-marital exam. His advice: Get married have a house full of children -

so it's all his fault!

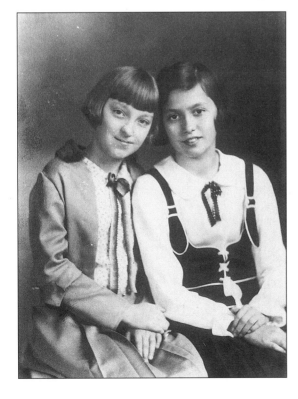

Mrs. Jim Colvin commissioned this portrait taken of her two daughters in the 1930s. (Davis.)

45

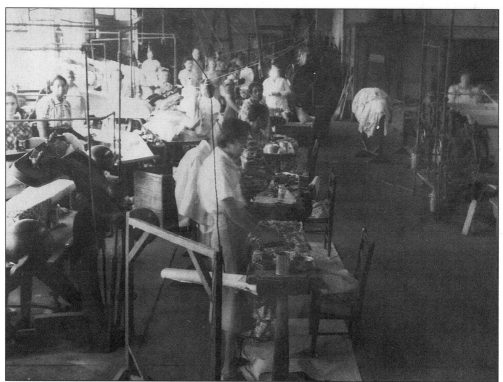

An interior shot of the Ruston Steam Laundry in 1940 shows workers going about their jobs. Many old timers have fond memories of having worked there. (Davis.)

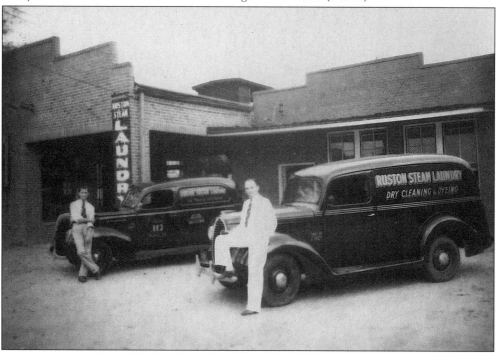

Delivery trucks and their drivers parked outside the Ruston Steam Laundry in 1940. (Davis.)

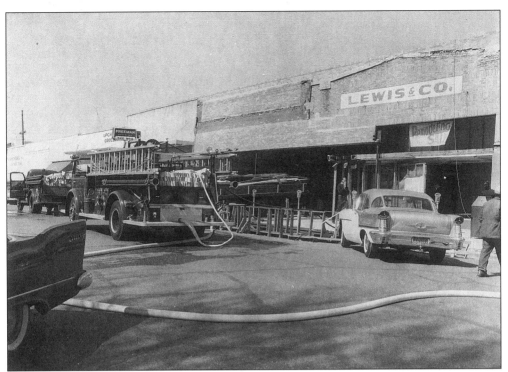

Lewis & Co., pictured during its fire of 1957, is still on Park Avenue across from Railroad Park. The front walls are out because the store was being remodeled at the time. The "Remodeling Sale" sign was not even damaged in the fire. (Woodward.)

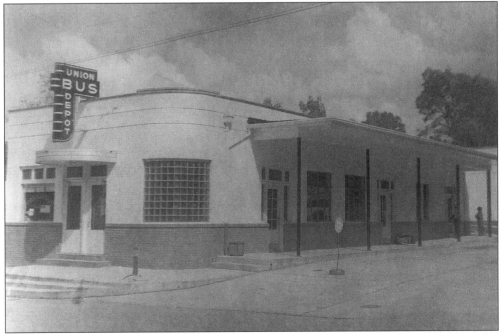

Many students' first sight when coming into Ruston to go to Tech was the bus station. This picture taken in 1940 could have been taken today. It has not changed much. (Davis.)

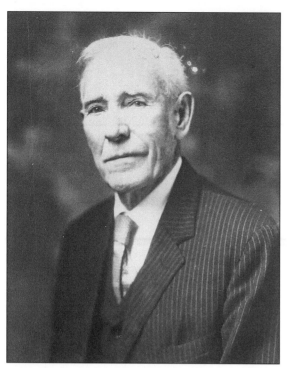

Ezekiel L. Holland was a partner in the Mays-Holland General Merchandise Store. Their business moved from Vienna when Ruston became a town. E.L. Holland died in 1926 just after this picture was taken. (Davis.)

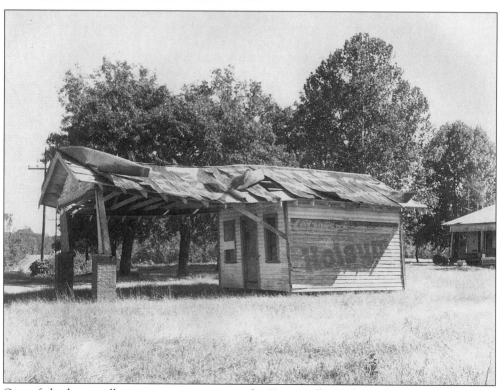

One of the last small grocery-gas stations on the Farmerville Highway has seen better days. (Pfister.)

# *Four*
# TOWN HAPPENINGS

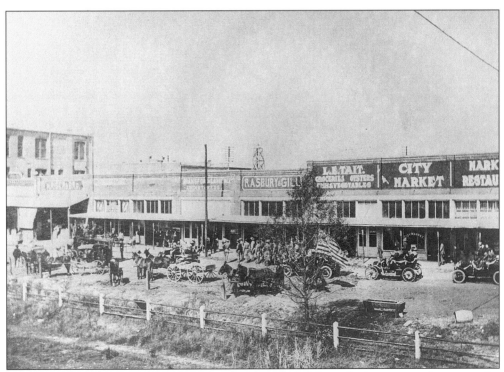

The 1905 Veteran's Day Parade at Railroad Park included the only three cars in Ruston at the time. The driver of the second car was W.A. Marbury Sr. (Marbury.)

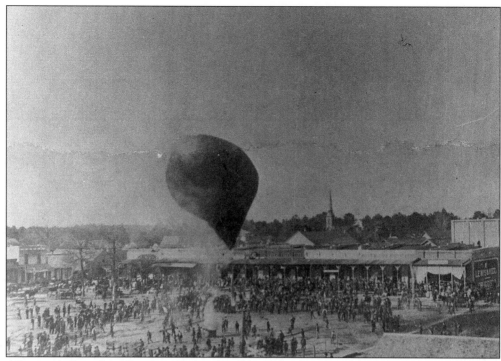

A hot-air balloon launches from Railroad Park in 1896. (Marbury.)

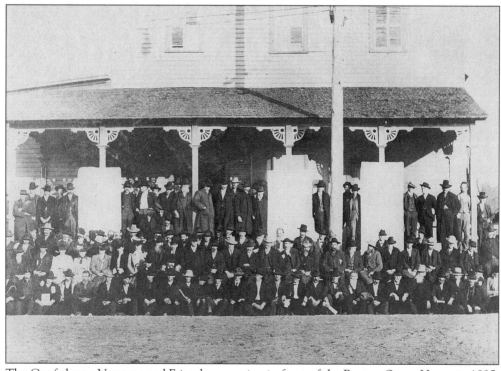

The Confederate Veterans and Friends are posing in front of the Ruston Opera House in 1895. The Opera House was located on the 100 block of North Bonner. (Marbury.)

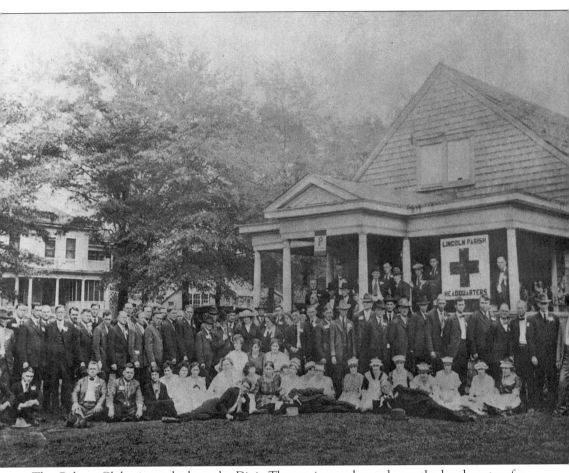

The Culture Club, situated where the Dixie Theater is now located, was the headquarters for many parish and town gatherings, both business and social. The women and men who stand in front of it were assembled for a Red Cross drive during World War I. They represented the business and professional people of the parish in 1917. (Marbury.)

Chautauqua, which was started in upstate New York, began here in Louisiana in 1892 and continued each summer until 1905. Pictured is the Chautauqua Auditorium in 1900. People would come from all over and stay for weeks to attend. (Davis.)

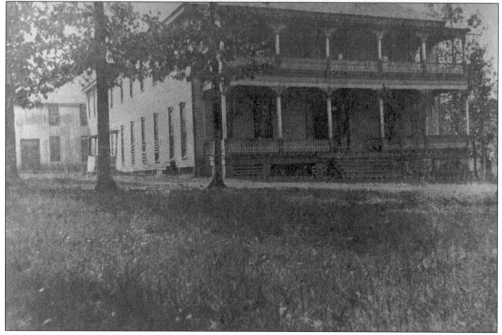

The Chautauqua Hotel, shown here in 1900, was built to accommodate people coming to the lectures. However, a lot of people still camped out while attending this summer lecture tour to bring culture to the rural areas. (Davis.)

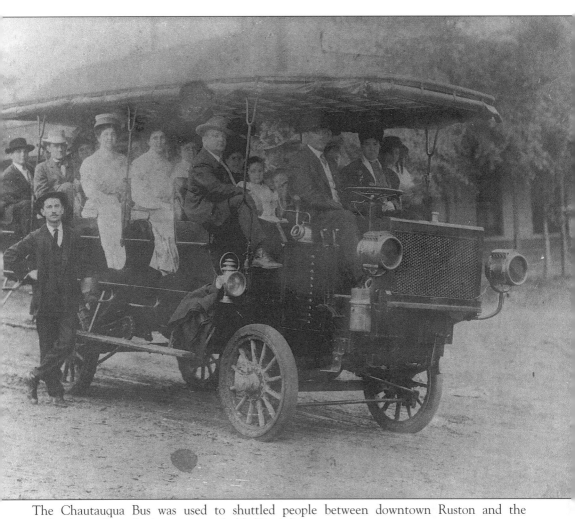

The Chautauqua Bus was used to shuttled people between downtown Ruston and the auditorium, where the lectures were held. (Davis.)

J. L. James' property - Toma Lodge - sits on this location.

We, the Allens, moved to Ruston in December, 1944 and rented a house directly across from the Chautauqua Rd. entrance to Toma Lodge. Our only neighbors were Mr & Mrs. Walter Farmer, caretakers who lived in a small house inside the fenced Toma Lodge near the entrance mentioned above.

In the year 2000 Toma Lodge was for sale and has been purchased by "Trot" Hunt to be developed into a gated community.

Bruce and I loved our years there and have lots of good memories.

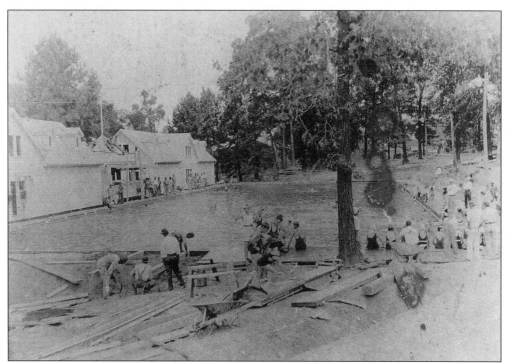

Swimming pools were becoming all the rage and Ruston was no different. In this 1930 picture, people are already swimming in the completed pool while the construction of the bathhouses goes on around them. (Davis.)

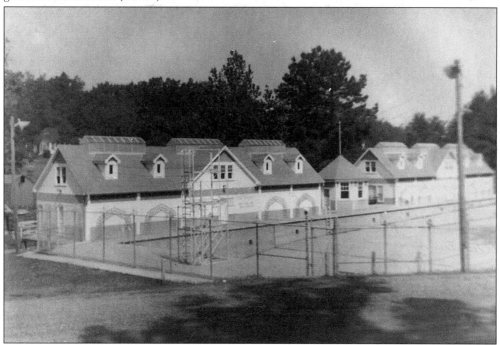

Here is the swimming pool and bathhouses in 1936. The swimming pool is still being used today by hot Ruston children, but the bathhouses are no longer there. (Davis.)

We had to walk through a foot disinfectant before we came out of the bath house. I suspect we got more germs than we avoided!

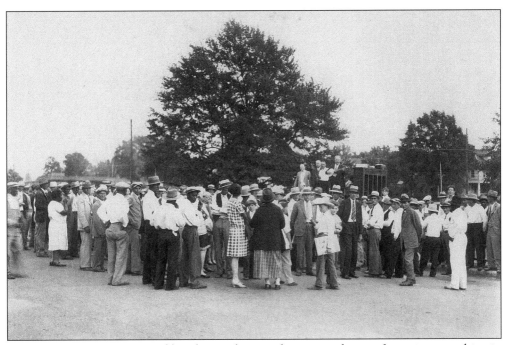

Ruston citizens are entertained by a banjo player as they wait in hopes of winning something in the Merchants Drawing of May 4, 1929. (Davis.)

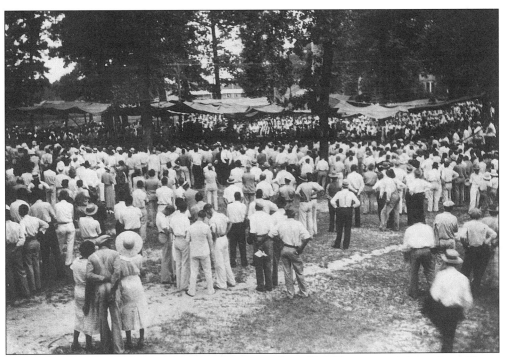

Most of Ruston turned out on August 30, 1934, to hear U.S. Secretary of Agriculture Henry Wallace speak. (Davis.)

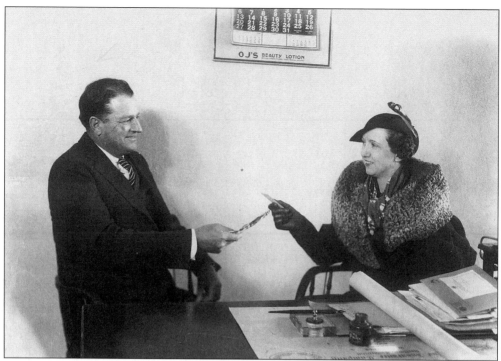

Mayor Goynes is purchasing the first ticket sold to the President's Ball from Mrs. Glen Laskey. A good time was had by all at this 1935 event. (Davis.) *Don & I attended Virginia Laskey's 90th birthday celebration at the Holiday Inn in Feb., 1990 - I think. She was a neat lady and my dear friend.*

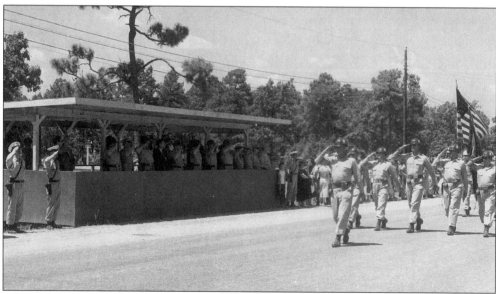

Guards at World War II Prisoner of War Camp, known as Camp Ruston, are reviewed. Most of the prisoners were Italians. (Davis.)

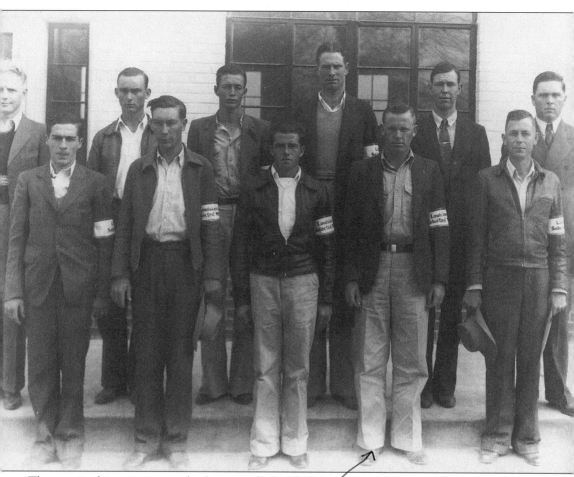

The men in this picture were the first men drafted for World War II from Lincoln Parish. They left Ruston on February 19, 1941, at 9:30 a.m. from the Trailway Bus Station. They are identified, from left to right, as follows: (front row) Wayne Edward Larance, Bentley Rogers Sumlin, Clarence Lehmon Traylor, and Louis G. Barnett; (back row) Joseph Wesley Denton, William Leon King, Robert Lee Hunt, John Willis Ambrose, John C. Joyner, and David Eldsworth Brown. (Davis.)

*Louie Barnett was a nephew of Uncle Newt and Aunt Esca Barnett. Jimmy Barnett looks a lot like this photo or did as a young fellow. Louie is the father-in-law of Raymond Germany, LTU basketball player (wife, Nelda) Robbie Jo Barnett Lee is my age and we were childhood playmates and were in Tech together. She now lives in Arcadia.*

In 1952 A & P & Jitney Jungle were adjacent stores. The Harris Clinic was upstairs in the Y. A. Harris Hotel. Kim was born here July 21, 1953 — Tuesday about 4:20 p m if my memory is correct—

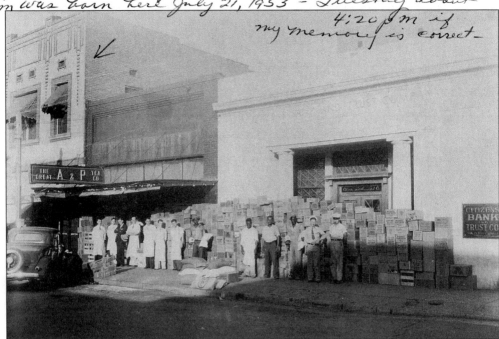

This view shows a Bundles for Britain food drive in 1941 at the A & P Grocery downtown. (Davis.)

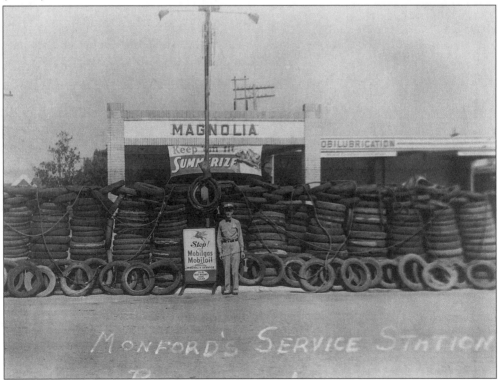

On July 24, 1942, tires collected for the war effort are pictured in front of Monford's Service Station in Ruston. (Davis.)

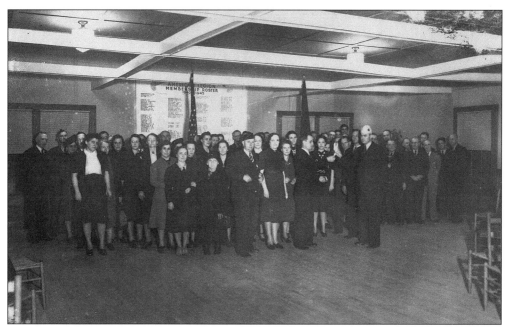

The American Legion burns their building note in 1947. This building is now the home of the North Louisiana Military Museum. (Woodward.)

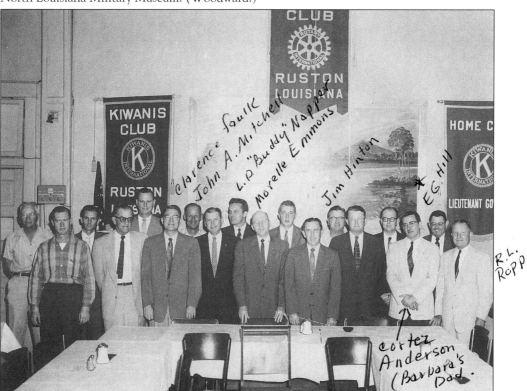

The Board of Directors of the Kiwanis had a breakfast meeting on September 14, 1956. (Woodward.)

*Mr. Hill hired Don and remained a friend to us. We bought our 1st Kelvinator & Maytag appliances at Hill Appliance. He always referred to me as "that little girl who was asked to close a cottage prayer meeting" by her dad. He never forgot it

59

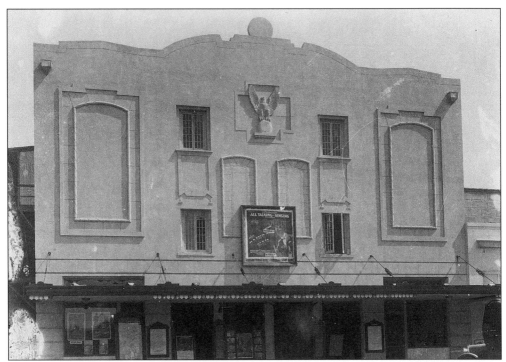

When the Dixie Theater was built by the Aster Company in the 1920s, it was known as the Rialto. Here in 1930, the theater is showing *The Rainbow Man*. (Davis.)

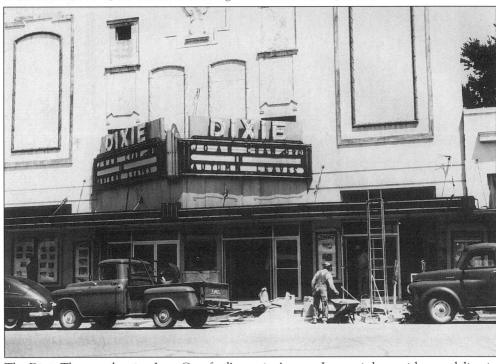

The Dixie Theater, showing Joan Crawford's movie *Autumn Leaves*, is busy with remodeling in 1955. (Woodward.)

"60 During our courtship we went to the "PREVIEW", Sat. night midnight show" nearly every weekend. And then to Hood's BarBQ for food and a coke.

*Five*

# SCHOOL DAYS

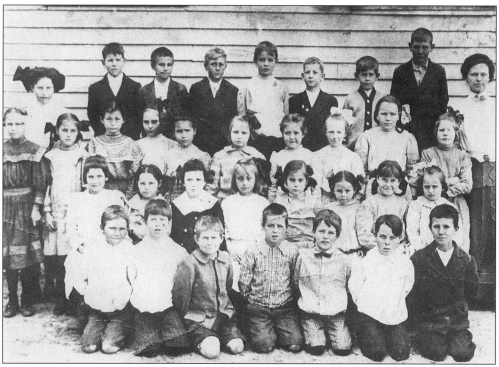

In the 1900s, the second- and third-grade schoolchildren at the Ruston School pose for a group portrait. (Davis.)

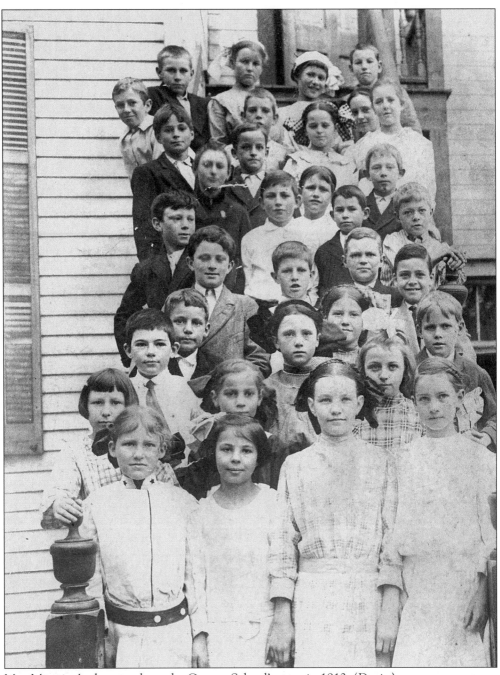

Mrs. Manning's class stands on the Cypress School's steps in 1912. (Davis.)

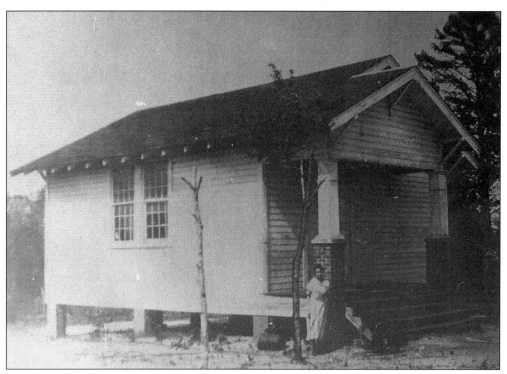

The Cypress School on Kentucky Avenue was one of the original one-room schoolhouses. The teacher poses in front of the school in 1920. Hillcrest Elementary is located there now. (Davis.)

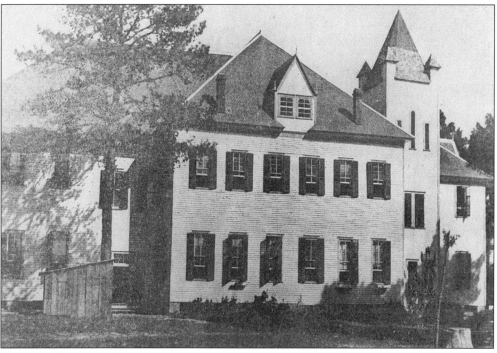

Ruston College, founded in 1889, was one of the first institutions of higher learning in the area. This building was located where the new city hall is today. (Davis.)

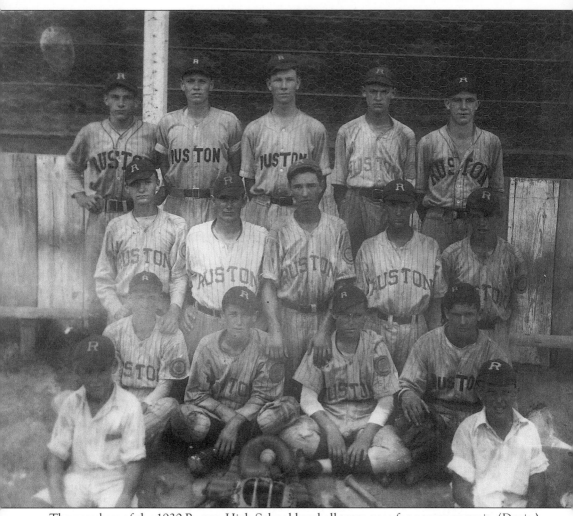

The members of the 1930 Ruston High School baseball team pose for a team portrait. (Davis.)

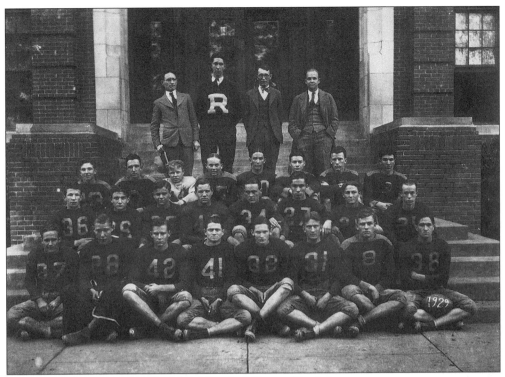

Here is the 1929 Ruston High School Football Team. (Davis.)

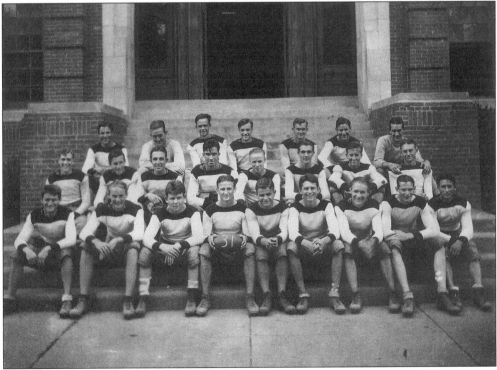

Members of the 1931 Ruston High School Football Team pose for a photograph. (Davis.)

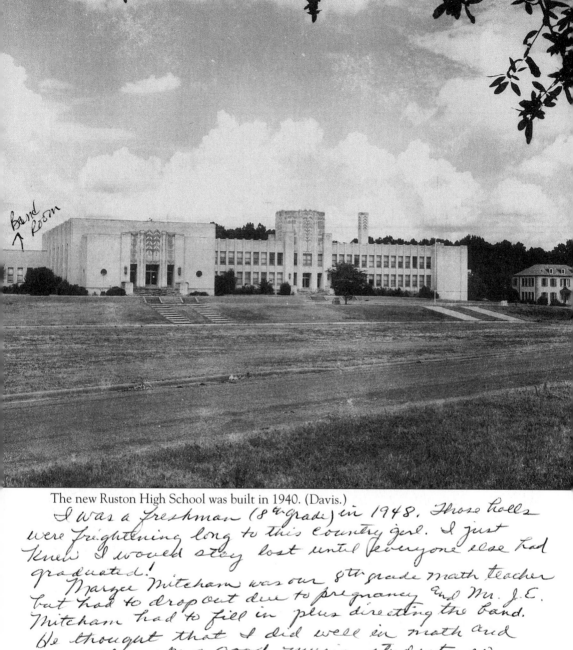

Band Room ↑

The new Ruston High School was built in 1940. (Davis.)

I was a freshman (8th grade) in 1948. Those halls were frightening long to this country girl. I just knew I would stay lost until everyone else had graduated!

Maryu Mitcham was our 8th grade math teacher but had to drop out due to pregnancy and Mr. J.E. Mitcham had to fill in plus directing the band. He thought that I did well in math and would make a good music student, so encouraged me in playing the flute —

I was never a good music student but that didn't keep me from enjoying four wonderful years going to festivals, football games, trips to New Orleans (where I had oysters every meal!)

Mr. Mitcham told me years later that he felt so responsible for all of us, the first time a boy took me home from band practice, he followed us!

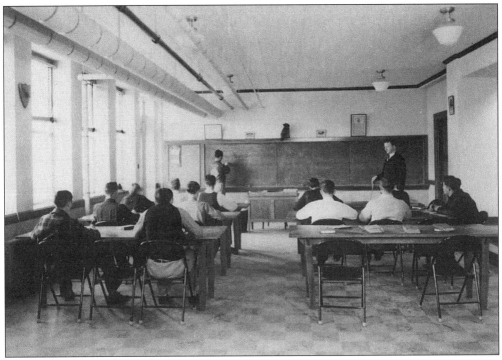

This is Mr. Henderson's shop class in 1941 at Ruston High School. (Davis.)

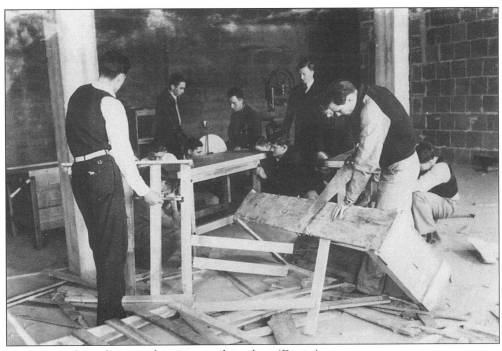

Students work on their wood projects in shop class. (Davis.)

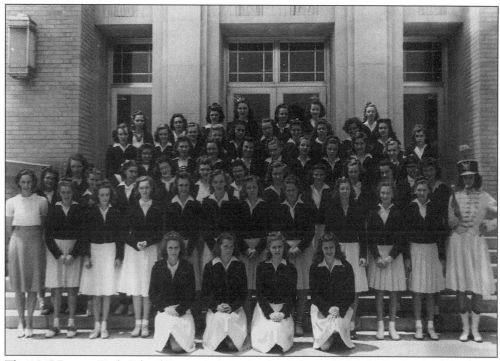

The 1947 Ruston High School Peppettes pose for their photo. (Davis.)

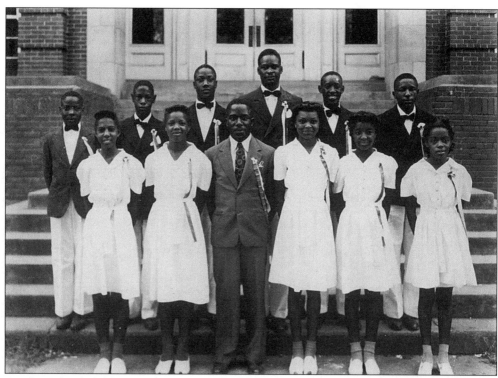

Ainsley School children compete at the Ruston Junior High in 1942. (Davis.)

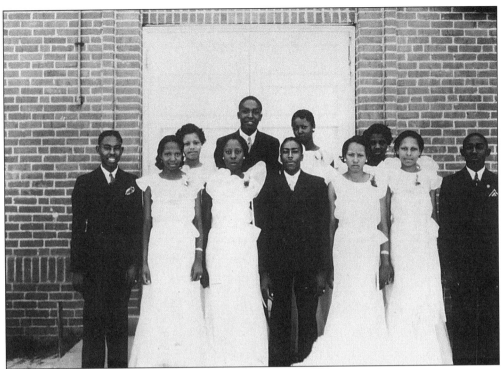

The 1939 Lincoln High School Graduating Seniors stand here. (Davis.)

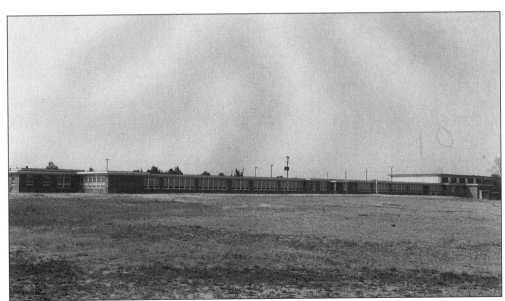

Here is Lincoln High School in 1956. The last class from Lincoln High graduated in 1970, but the building is still used by the school system. (Woodward.)

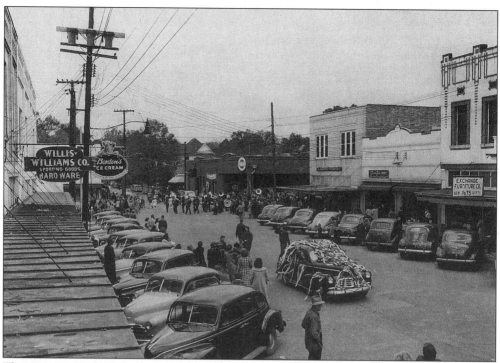

The Ruston High School 1948 Homecoming Parade winds its way through downtown. (Woodward.)

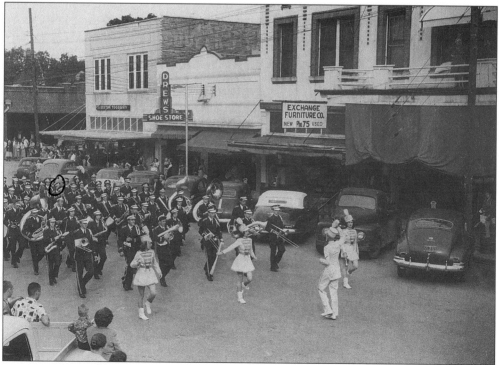

Ruston High School's marching band performs in the 1949 Homecoming Parade. (Woodward.)

70 *I wonder why he had me hidden way back there?*

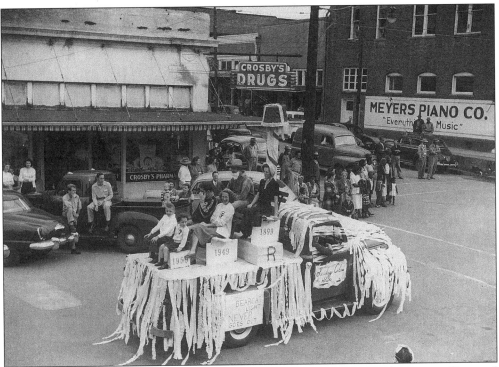

Ruston High's Homecoming parade is a town event. This float carries the current King and Queen of 1949, with students portraying the past King and Queen of 1899 and children representing the future King and Queen of 1959. (Woodward.)

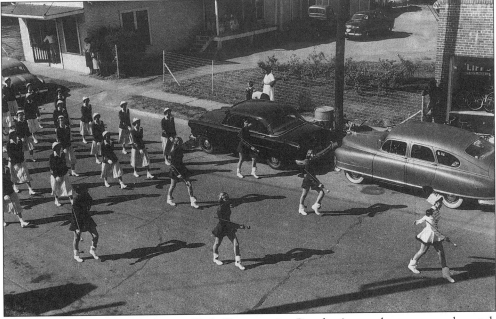

Students march in the 1952 Ruston High Homecoming Parade. Across the street people watch from the Southwest Natural Gas Company (which is now the Arkla/Reliant Gas Co.) and Cliff's Bicycle Shop (where New York Life is now). (Woodward.)

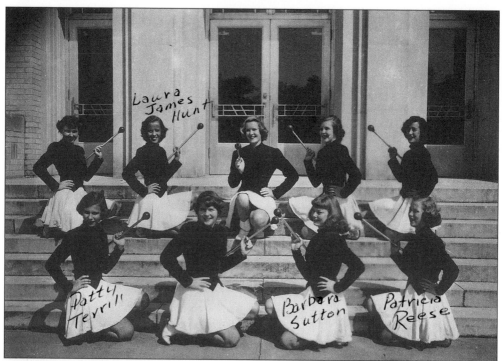

The 1948 Ruston High School Drum Majorettes kneel for a picture. (Woodward.)

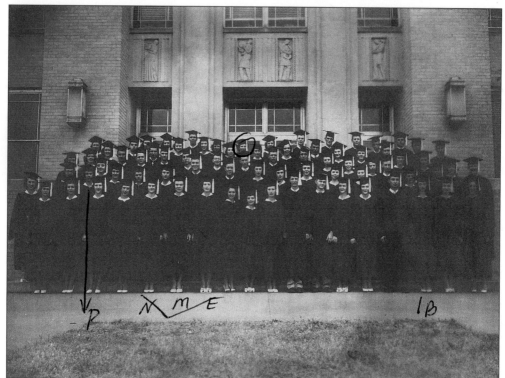

The 1951 Ruston High School Graduating Seniors stand in their cap and gowns. (Woodward.)

Again, & never front row and center but Norma Robinson, Mary Adney and Esmerelda Coker are! and Barbara Pat Ingram 2nd row

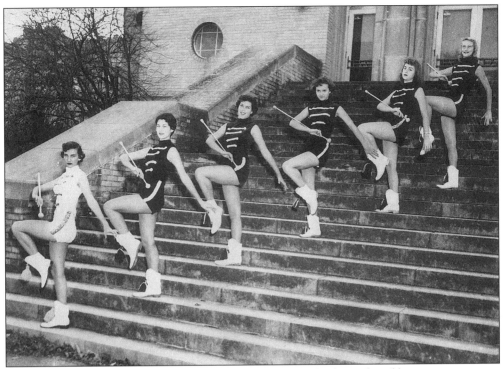

The Ruston High School Twirlers pose on December 5, 1956. (Woodward.)

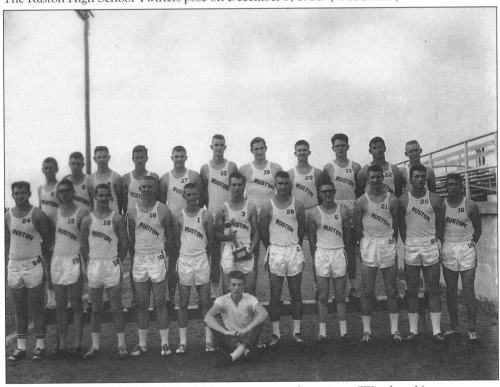

The 1959 Ruston High School Track Team were state champions. (Woodward.)

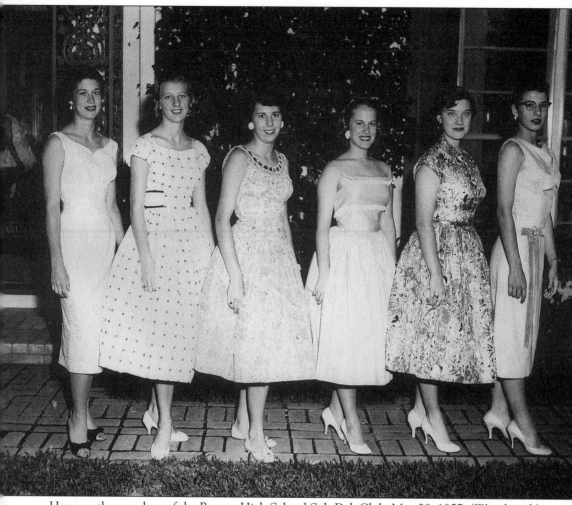

Here are the members of the Ruston High School Sub-Deb Club, May 29, 1957. (Woodward.)

*Six*

# GO BULLDOGS!

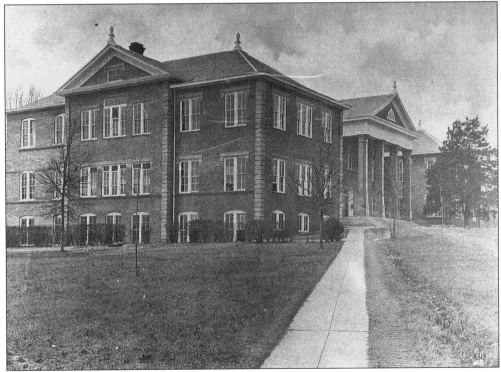

Old Main was much bigger than we might imagine, filling most of the space that is now the quadrangle. This photograph was taken for a series of postcards on Ruston. (Davis.)

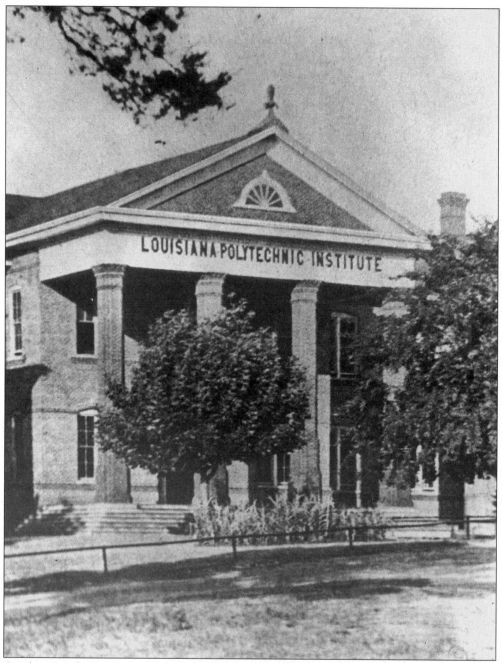

Combining administration, auditorium, and regular classrooms, Louisiana Tech University's Old Main burned in December of 1936, destroying most of the schools records. (Davis.)

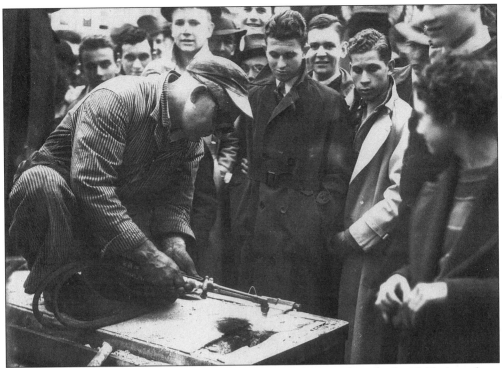

The heat of the fire that destroyed Old Main fused the door on the safe closed. Tech students watch as a workman uses a blow torch to open the massive safe containing files in January of 1937. (Davis.)

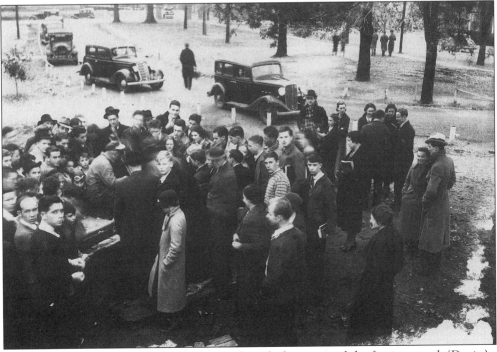

A crowd gathers at the ruins of Old Main as the safe that survived the fire is opened. (Davis.)

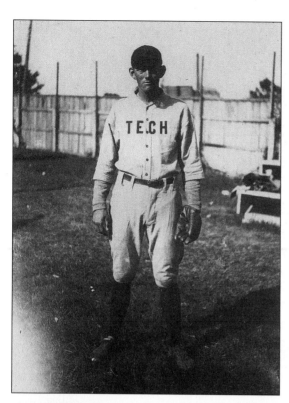

An unidentified 1931 Louisiana Tech baseball player poses in his uniform. (Davis.)

On October 7, 1934, the Louisiana Tech Cheering Squad consisted of, from left to right, Jo Ellen Posey, Sonny Matthews, Nan Morgan, and Skeets Coats. (Davis.)

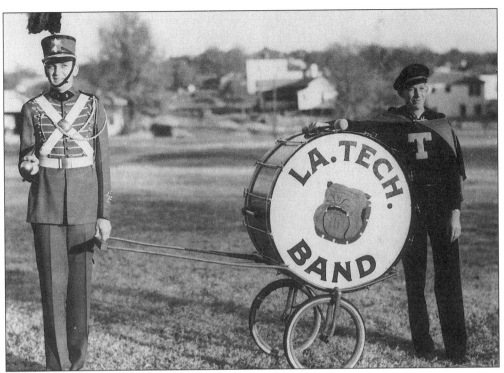

Tech Band members prepare to march onto the field in 1937. (Davis.)

This is Elizabeth Bethea in 1939. She was the head of the Tech Art Department. (Davis.)

Mr. Davis did all the *Lagniappe* (Tech yearbook) pictures in the 1930s. This picture of Charlotte Davis was taken for the yearbook in December 1933. (Davis.)

J.B. Colvin's picture was taken for the Omega Kappa fraternity page in the 1932 *Lagniappe*. (Davis.)

On January 26, 1935, William A. Marbury's picture was taken for the *Lagniappe*. (Davis.)

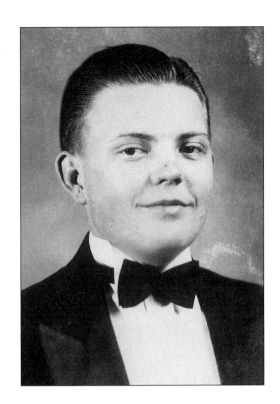

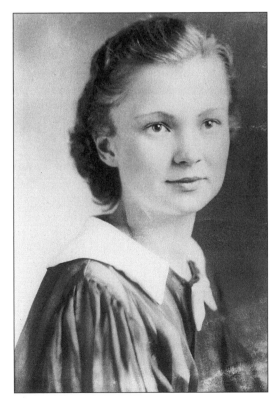

This is Virginia Lomax's picture for the *Lagniappe* in 1934. She later married William A. Marbury. (Davis.)

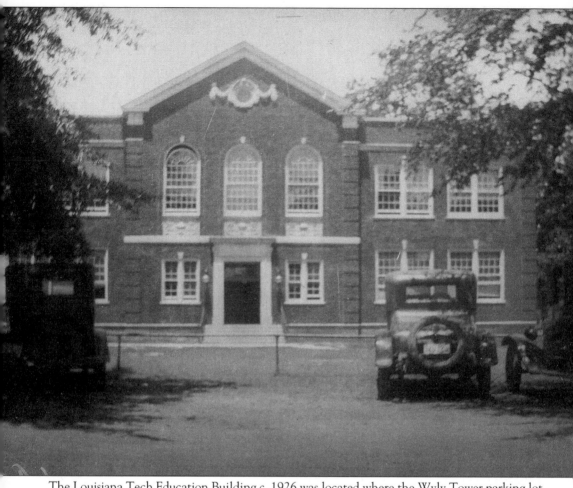

The Louisiana Tech Education Building *c.* 1926 was located where the Wyly Tower parking lot is today. (Davis.)

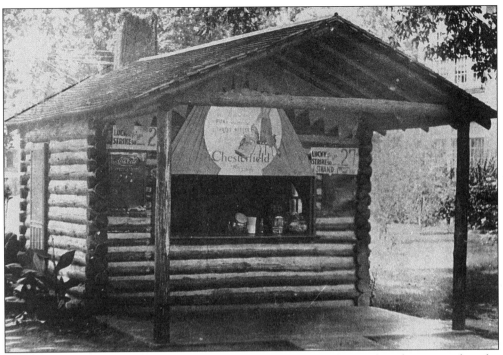

The Log Cabin concession stand, which sat in the middle of the quadrangle, was used in the early 1940s before the Tonk was built. (Davis.)

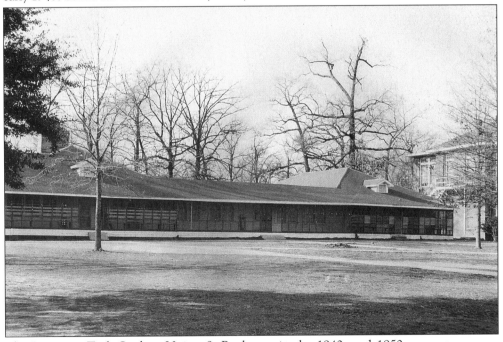

The Louisiana Tech Student Union & Bookstore in the 1940s and 1950s was a temporary structure built after World War II. Used for about 15 years, it consisted of old army barracks, and was known as the "Tonk" because it looked like a honky tonk. The "new" student center built in 1958 is still known as the "Tonk." (Pfister.)

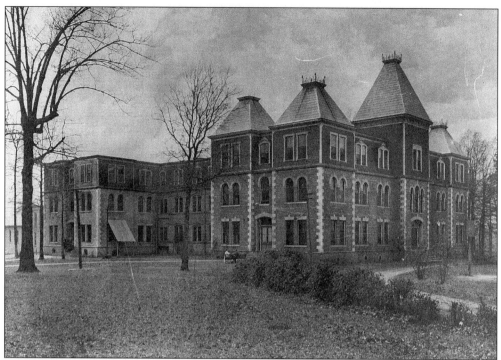

Hale Hall is shown here in 1900. This photograph was used in a series of postcards of Ruston. (Davis.)

This is Hale Hall 85 years later—notice the changes. The peaked roofs were removed in the 1950s. (Pfister.)

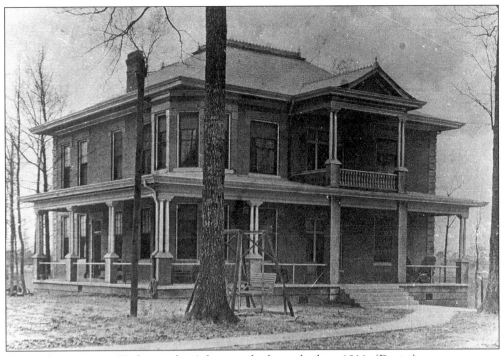

This is the Louisiana Tech president's home, which was built in 1911. (Davis.)

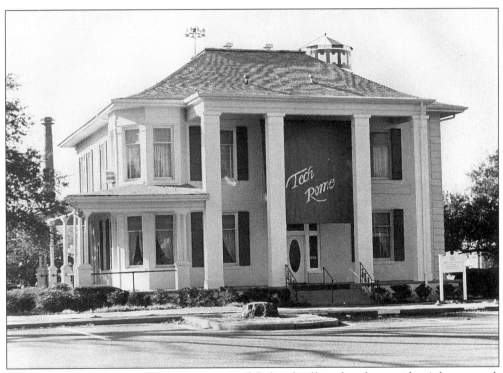

Many years later, this same building was remodeled and still used as the president's home until the 1960s. It is now the offices of Tech Rome. (Pfister.)

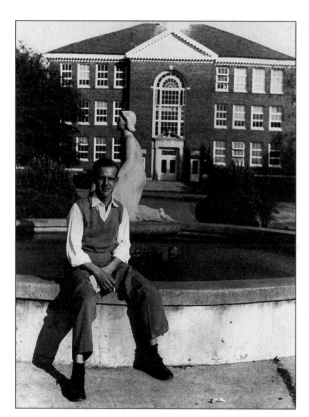

Bob J. Pfister sits on the fountain in the quadrangle at Louisiana Tech in 1952. Keeny Hall is in the background. (Pfister)

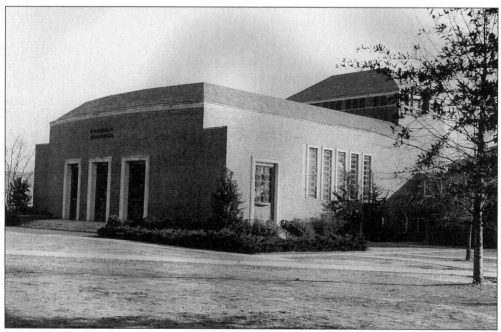

Howard Auditorium, named after Harry Howard, the first graduate of Louisiana Tech, was built in 1941. (Pfister.)

This is a view of the Louisiana Tech quadrangle in 1952 from the second floor of Keeny Hall. The old English building that can be seen across the quadrangle is where the campus bookstore is now located. However, it cannot be seen through the giant live oaks that have grown tall over the years. (Pfister.)

I well remember a Monday, March 29, 1952 when I stood on the 1st floor under this same window and told the guy I had been dating that I had met the man (Don) that I was going to marry. I had met him just the day before at Emmanuel Baptist Church; He came with Ted Gullatt.

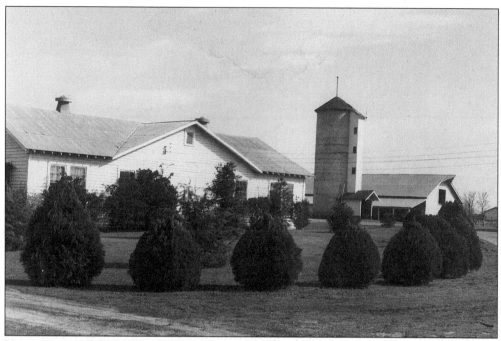

Here are some of the buildings at the Tech Farm in 1953. (Pfister.)

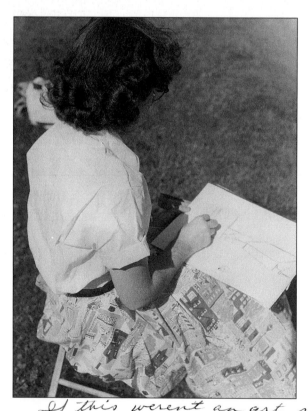

This Louisiana Tech art student is making sketches at the Tech Farm in the early 1950s. (Pfister.)

If this werent an art student, I would have thought it was me: right size, right color & length hair and the skirt looks familiar! No art for me, though!

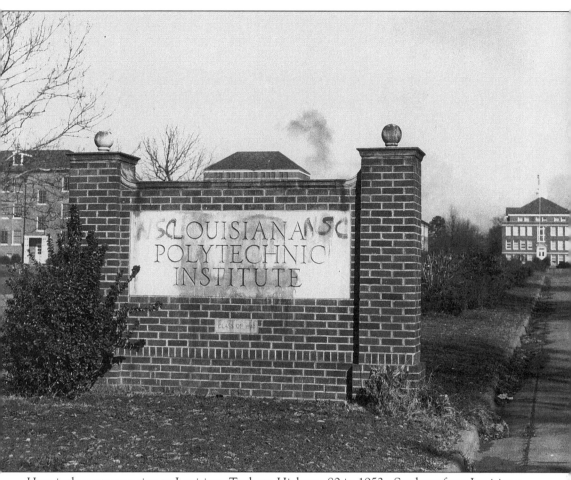

Here is the entrance sign to Louisiana Tech on Highway 80 in 1952. Students from Louisiana College and Northwestern State College have left their mark on Tech. (Pfister.)

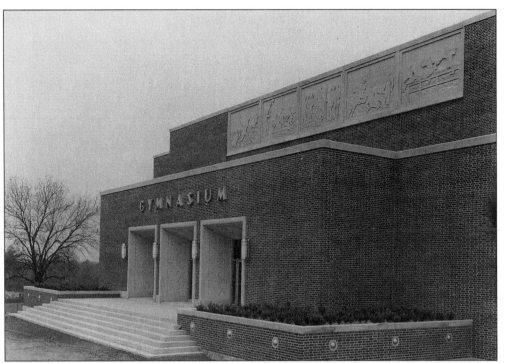

The Louisiana Tech Memorial Gymnasium is pictured here just after its completion in 1952. (Pfister.)

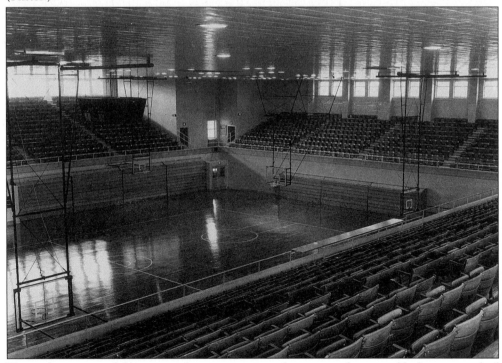

This is the interior of the memorial gymnasium just after its completion and before anyone had played a game on the highly polished floors. (Pfister.)

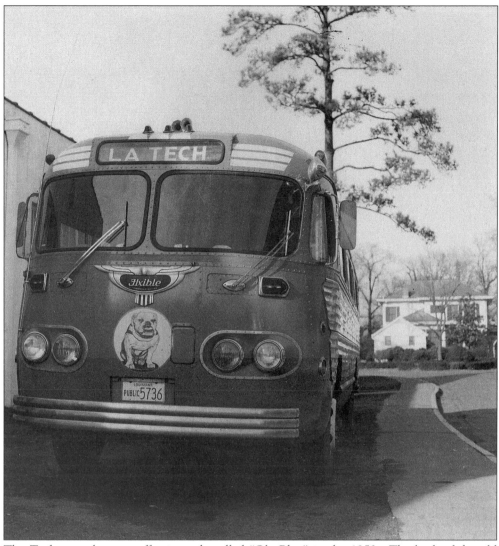

The Tech team bus was affectionately called "Ole Blue" in the 1950s. The back of the old president's home can be seen on the right. (Pfister.)

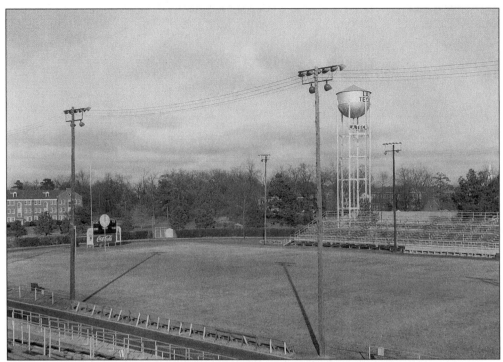

The old Tech Football Stadium in 1952 was located where the A.E. Phillips Laboratory School is now. (Pfister.)

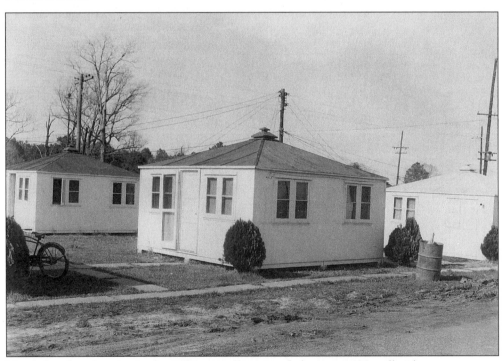

Married student housing in the 1950s was affectionately known as "Vetville," because so many students were returning service men. (Pfister.)

*Kim's very first home, July, 1953, was very much like this. Rent, $20.00/per month included utilities. "Pop" Allen had linoleum installed in our kitchen.*

92

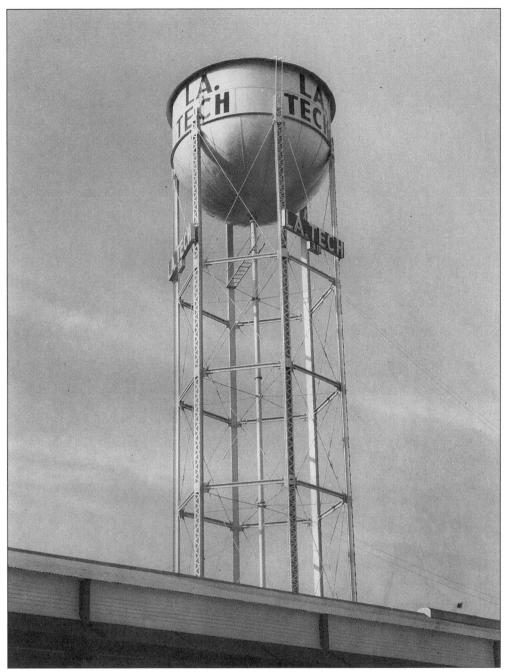

Here is Louisiana Tech's water tower. (Pfister.)

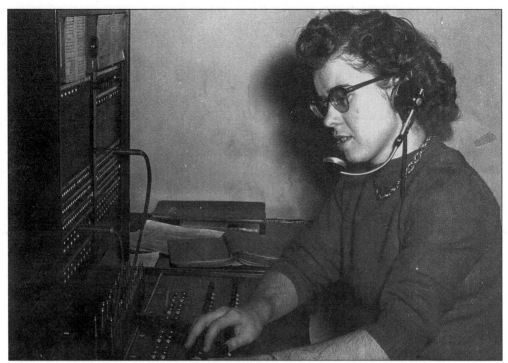

Bettie Anne Bauguss works at the Louisiana Tech switchboard in 1953. She was one of the first student operators when Tech got its own telephone system. (Pfister.)

Harper Hall was Louisiana Tech's girls' dormitory in 1952. Now, Harper is an eight-story high-rise in the same location. (Pfister.)

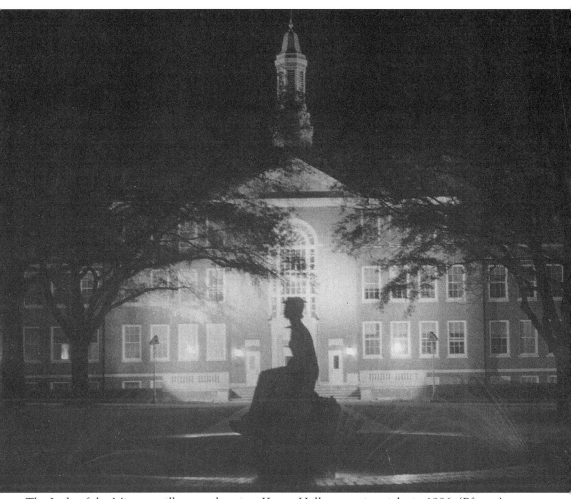

The Lady of the Mist was silhouetted against Keeny Hall on a quiet night in 1986. (Pfister.)

Wyly Tower makes a modern backdrop for the four driveway entrance posts left when Old Main burned. (Pfister.)

I had just begun working in Prescott Library when Wyly Tower was begun. Gov. Edwards and other dignitaries were there for the ground-breaking ceremony.

*Seven*

# ONE BIG FAMILY

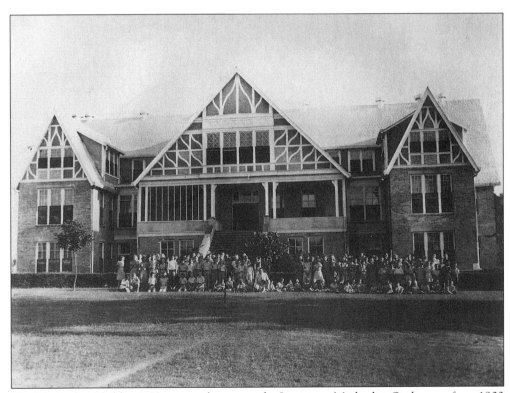

The Methodist Children's Home was known as the Louisiana Methodist Orphanage from 1903 to 1960. This main building was used for over 50 years. (Davis.)

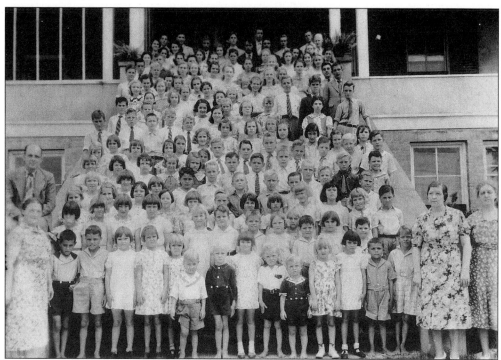

All of the children gathered for a portrait on the steps of the main building in 1934. (Davis.)

This is the Whiled Miller Cottage. (Davis.)

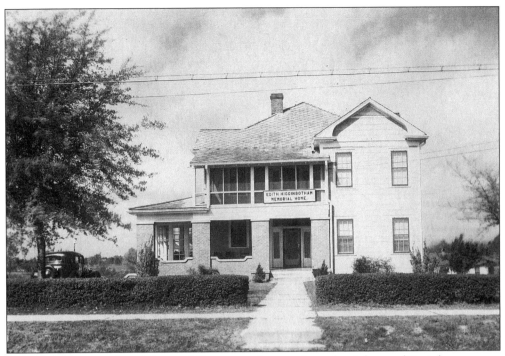

The Edith Higginbotham Memorial Home was the superintendent's house. (Davis.)

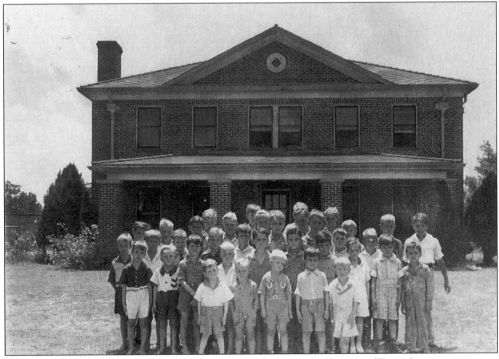

The younger boys stand in front of their home, The Harmon Cottage. (Davis.)

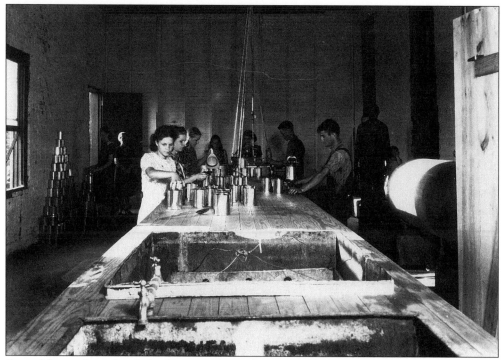

One of the products that helped support the orphanage, Ribbon Cane Syrup, is being canned in this picture. (Davis.)

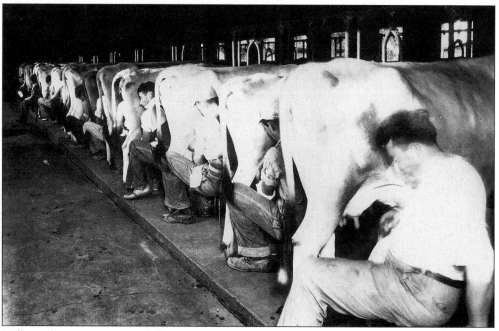

Milking the cows was one of the boys' chores. (Davis.)

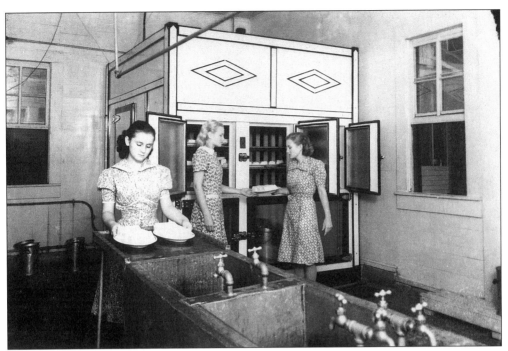

The girls put away freshly churned butter inside the "Milk House." (Davis.)

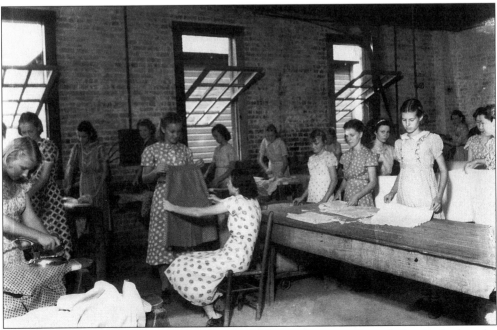

Other chores that the children had to do were folding and ironing their clothes in the laundry room. (Davis.)

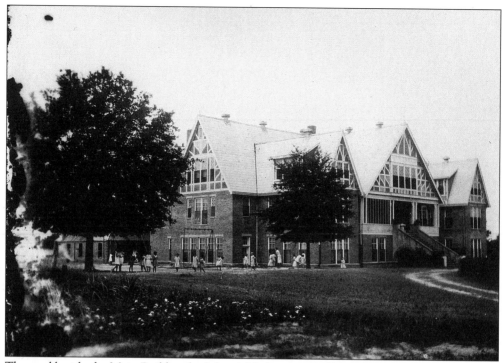

The yard beside the Main Building had the girls' playground. (Davis.)

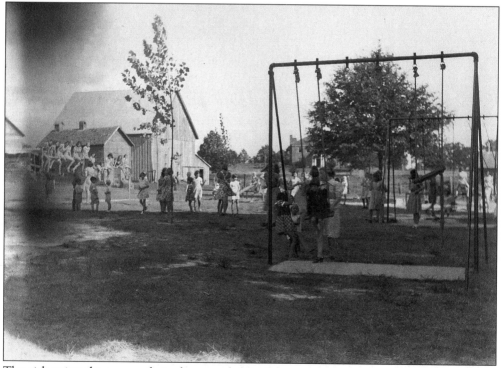

The girls enjoyed recess on their playground. (Davis.)

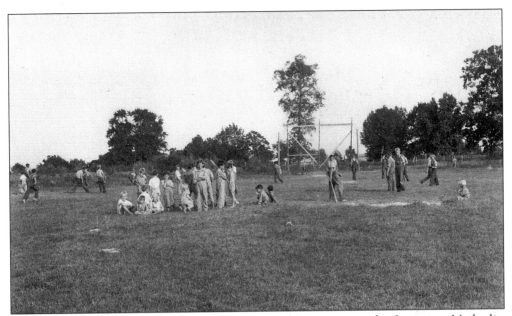

"Batter Up!" The little boys of summer prepare for a game at the Louisiana Methodist Orphanage. (Davis.)

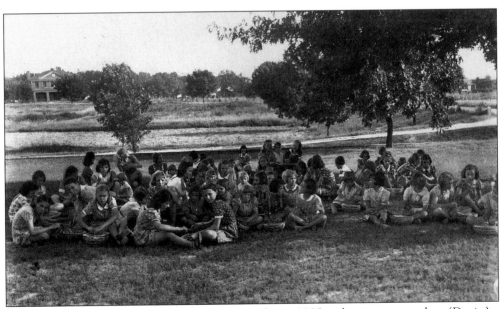

These children sit in the shade on a hot summer day in 1935 and enjoy watermelon. (Davis.)

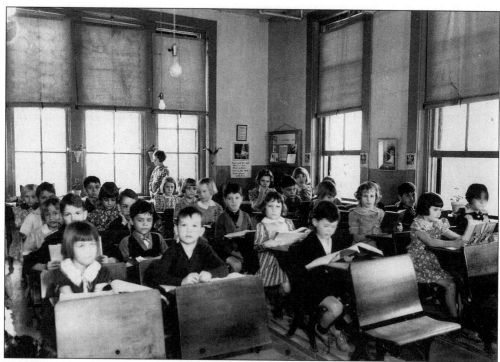

The first and second grade class is ready to learn. (Davis.)

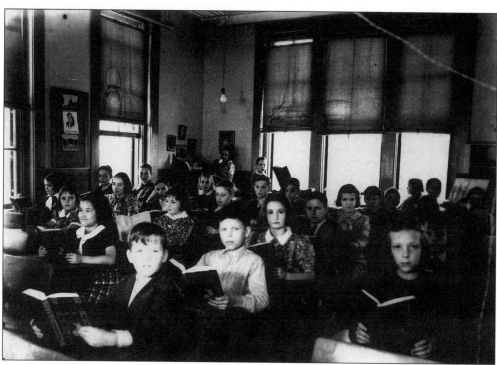

The third and fourth grade class take a break from their reading for a picture. (Davis.)

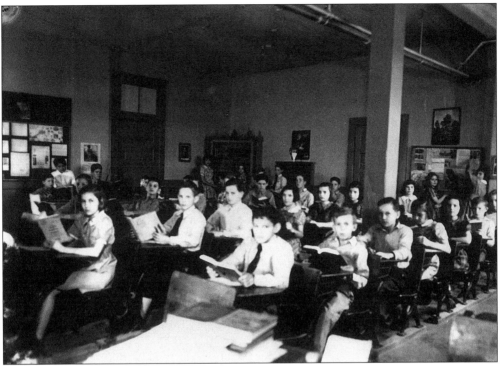

The fifth and sixth grade class shows what they have been studying. (Davis.)

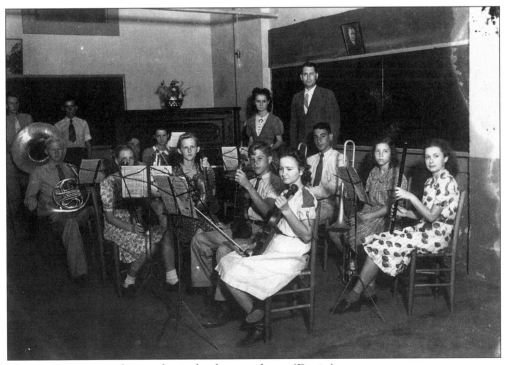

The music session is about to begin for these students. (Davis.)

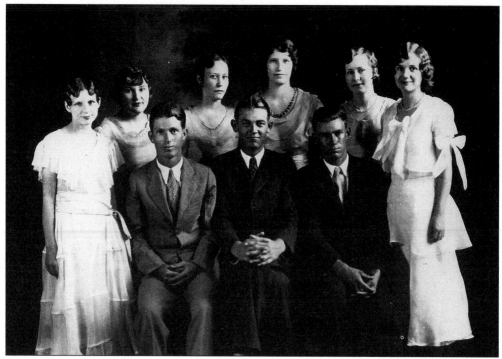

These students are all dressed up for graduation in 1931. (Davis.)

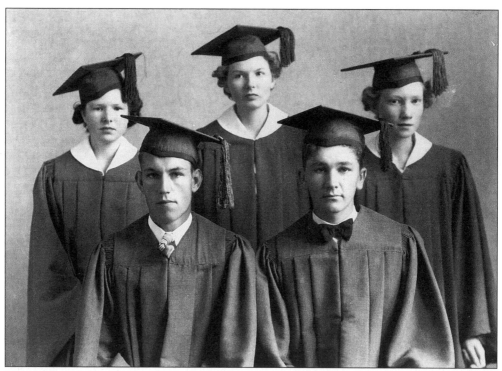

Five graduated from Ruston High at the Louisiana Methodist Orphanage on May 27, 1938. (Davis.)

*Eight*

# HEART AND SOUL

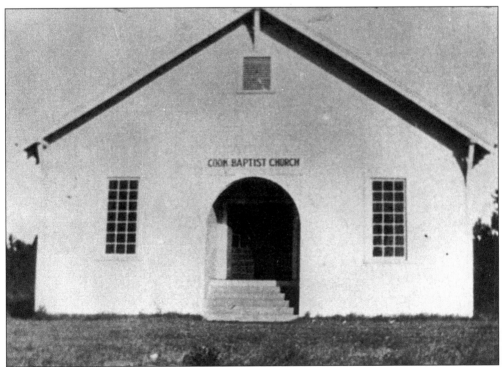

Here is the original Cook Baptist Church in 1930 before it was moved across the street. It is now incorporated into the present building. (Davis.)

John, Lil and I walked from our home on Chautauqua Road to Cooktown to church until Temple Baptist begun a bus ministry in the late '40's. (approx 1948)

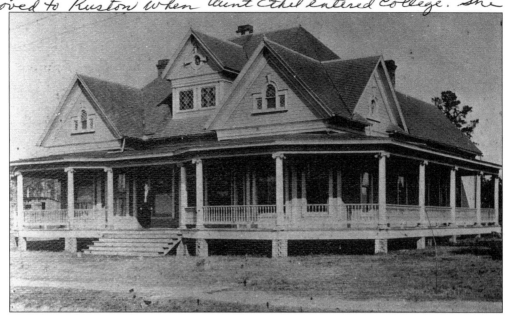

The Buie House on Mississippi Avenue is shown here in 1910, just after it was built. When Mr. Buie died, his wife turned it into a boardinghouse to support her family. (Davis.)

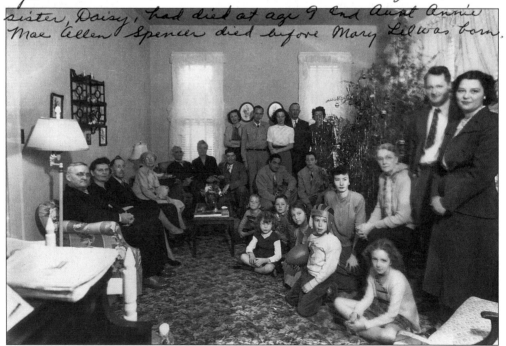

The Ellis family gets together for Christmas in 1941. (Davis.)

108

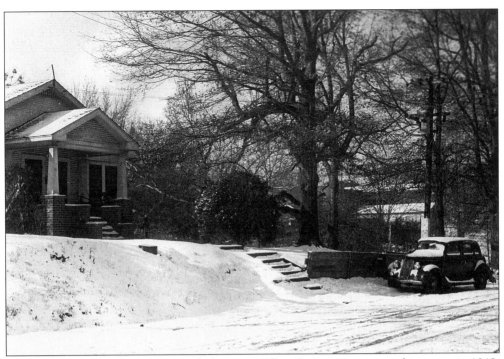

Edwin "Red" and Gladys Woodward's home on West Georgia was covered in snow in 1949. Many of the negatives used to print pictures for this book spent 30 years in a shed behind this house. (Woodward.)

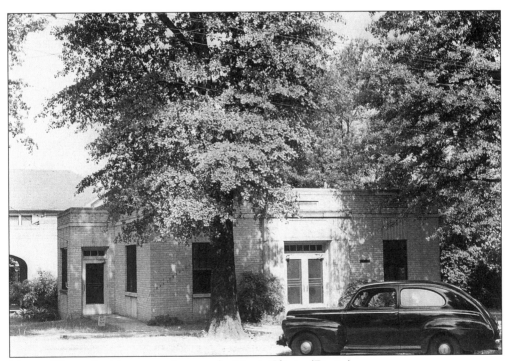

Many of Ruston's citizens were born at the Harris Clinic. (Davis.)

Kim was born at the Harris Hotel, located upstairs over
A & P and Jitney Jungle, on July 21, 1953 after
Keith, Keri & Kevin all born at Harris Clinic after
it became Thomas-Kimbell; Kirk came later, Nov 21, 1960 at
Lincoln General Hospital.

Drs. Frances and Willie Fletcher were maiden sisters who lived in this house and taught at Louisiana Tech for over 30 years. (Pfister.)

This is now the Twin Gables Bed & Breakfast. (Pfister.)

Mrs. Drew "Baby" Hays, a well-known artist who published three books of drawings of the Ruston area, lived here. (Pfister.)

This is Mrs. Drew "Baby" Hays on September 23, 1940. (Davis.)

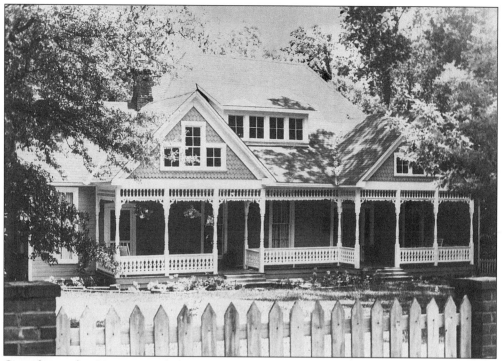

One of many fine Victorian-style homes in Ruston today is the Meadows house. (Pfister.)

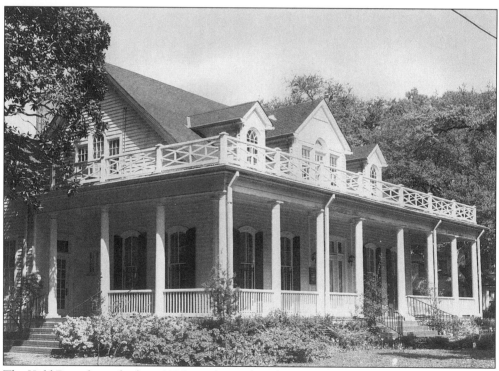

The Kidd Davis home built in 1886 was donated to the city and now houses the Lincoln Parish Museum. (Pfister.)

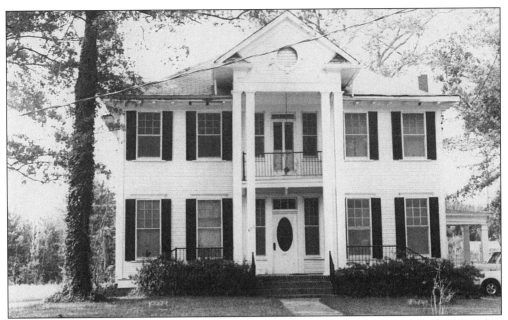

The Stockbridge House was originally built as a hospital. A unique feature of the house is that all the corners in the rooms are curved for easy cleaning. (Pfister.)

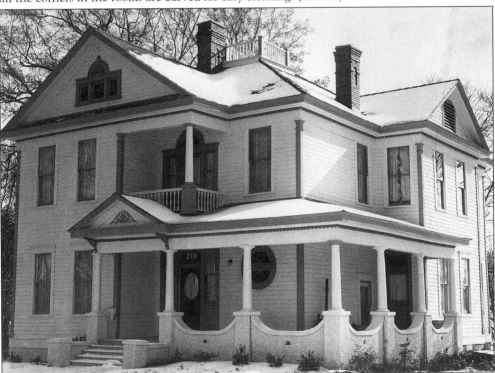

W.A.J. Lewis Sr. and his wife, Kaletha, built this house in 1901. They moved to Ruston from Trenton (now West Monroe) and opened their business, Lewis Department Store. John and Margaret Colvin bought and restored it in 1987, and they operate it as an antique store. (Pfister.) *Margaret Pesnell Colvin is a cousin to Pa (Prentes) Her father was a brother of Annie Pesnell Belton, wife of Will Belton —*

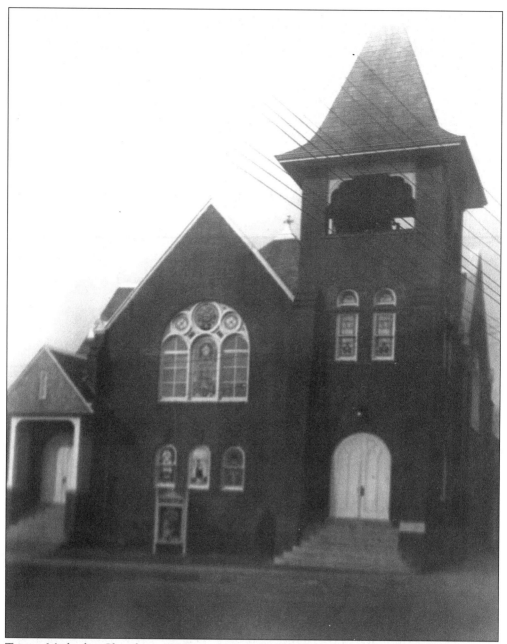

Trinity Methodist Church, c. 1920, was built before N. Trenton was paved. The main part of this building was torn down in the 1930s, and the back part has been used as stores ever since. If you walk along the north side of the building you can see the old arched windows that were bricked in. (Davis.)

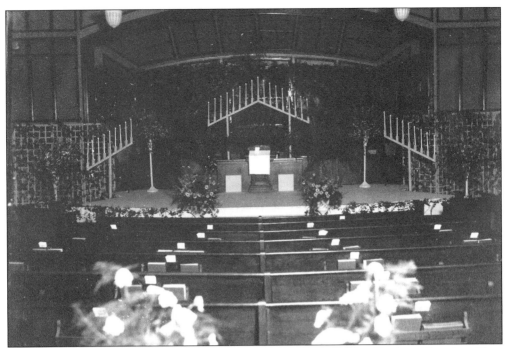

The interior of the "New" Trinity Methodist Church is decorated for Charlotte Davis' wedding in 1933. (Davis.)

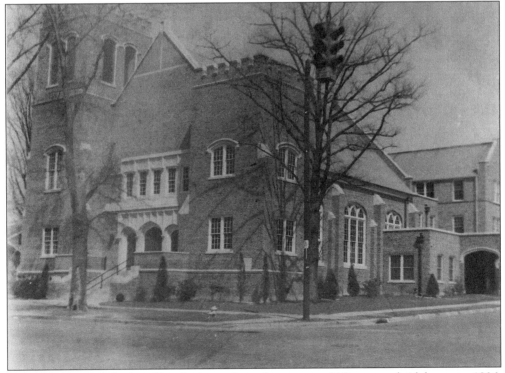

This is Trinity Methodist Church, located on the corner of Vienna and Alabama in 1936. (Davis.) *Martha Sue Lewis and Aubrey Wayne Kinnaird were married in this Trinity.*

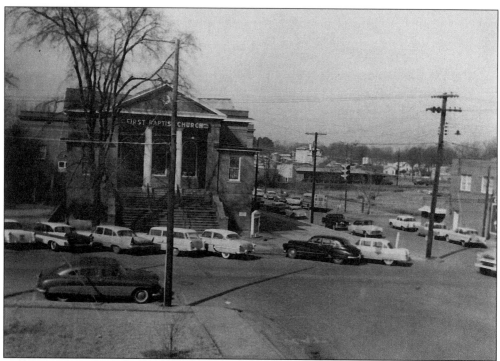

This is the view of First Baptist Church in 1957 as seen from the second floor of the courthouse. (Woodward.)

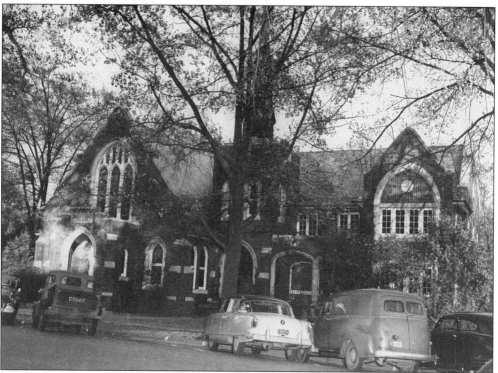

Here is the First Presbyterian Church in the 1950s. (Woodward.)

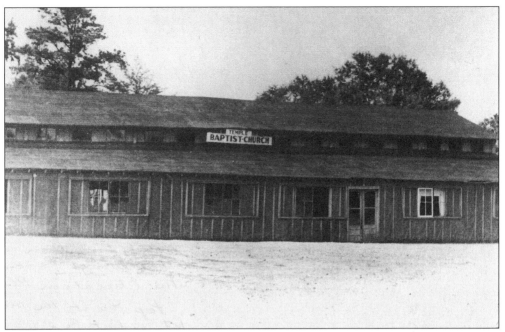

Temple Baptist Church is pictured in 1914. (Davis.)

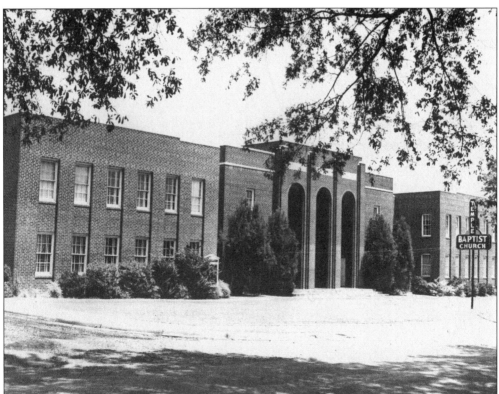

Temple Baptist Church, shown here in 1955, has grown quite a bit. (Woodward.)

We were active at Temple during my high school years,
1948-1951. James and Evelyn Davison worked with
teen agers and meant the world to all of us. Evelyn shared
the outgrown clothes of her grandchildren with you Belton K's

117

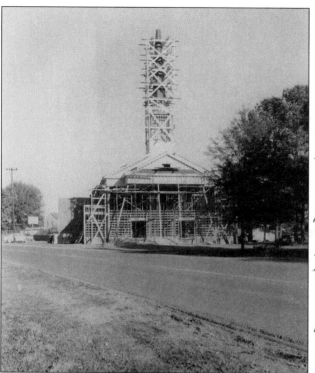

Emmanuel Baptist Church was under construction in the 1950s. (Woodward.)

"Pop" Allen was a charter member of Emmanuel, instrumental in its formation.

Lil and Mary Lil moved their membership during the summer tent revival of 1951.

The congregation 1st met in the old Eastland Elementary School and then in what would become the Education Bldg.

Pop built the very 1st pulpit and communion table used at Emmanuel in the Education Bldg.

Bruce Allen pulled it from storage for the 50th anniversary in 2000. And probably has it back in his barn.

We took photos and will share them.

Peggy Bartlett and Paul Johnson (Dexter's parents) were the 1st couple to marry at Emmanuel — we were the second (Education Bldg.)

Emmanuel Baptist Church is now completed, but the workmen still need to clean up some of their mess on the right of the building. (Woodward.)

We were married in the Education Bldg. on Sunday evening, Sept. 28, 1952, after the evening church service. Bruce and Wanda married exactly one month later, Oct.

# *Nine*
# FROM ABOVE

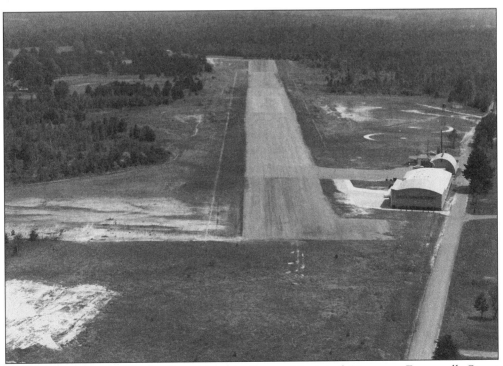

This is an aerial view of the landing strip at the Ruston Municipal Airport on Farmerville Street in 1957. (Woodward.)

Don paid $1.00 for a 30 minute flight over Ruston with Mr. Stuckey when he was about 12. A yellow cub!

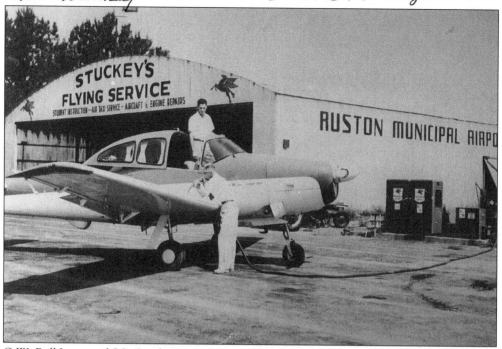

G.W. Bull Jones and S.L. Stuckey are gassing up their plane at the Ruston Municipal Airport in 1951. In the background you can see the hanger for Stuckey's Flying Service. (Woodward.)

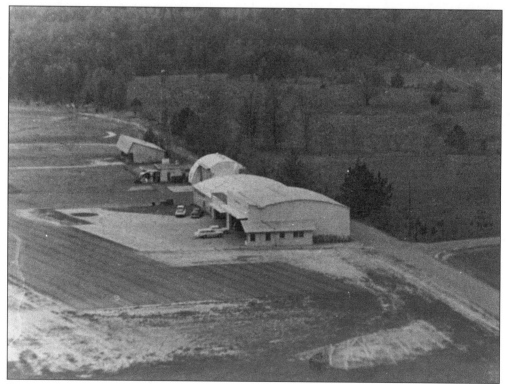

By 1962 the airport had more hangers and more business. (Woodward.)

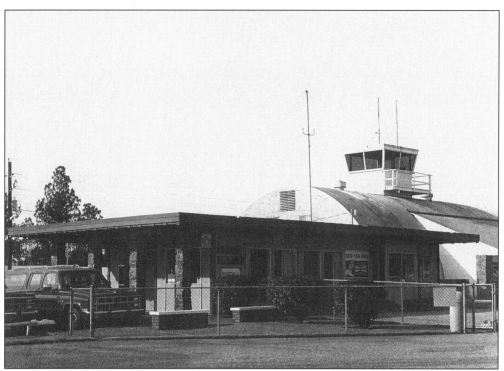

The Ruston Airport terminal is seen beside the Louisiana Tech building on the right in the 1980s. Tech's professional aviation program is nationally known. (Pfister.)

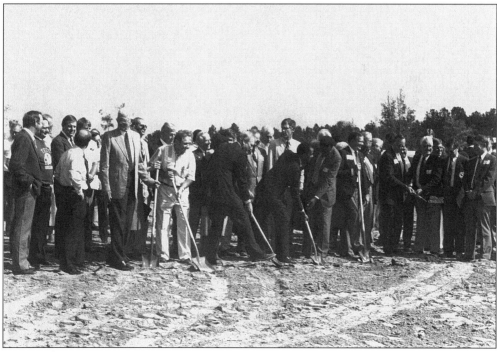

On October 13, 1989, ground was broken for a new airport, 2 miles out on the Chatham Highway. (Pfister.)

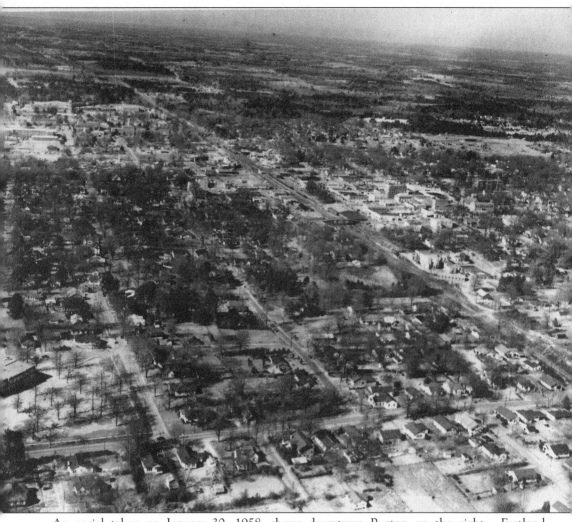

An aerial taken on January 30, 1958, shows downtown Ruston on the right. Eastland Elementary School is in the bottom left corner where the school board office is today. Louisiana Tech is at the top left. (Woodward.)

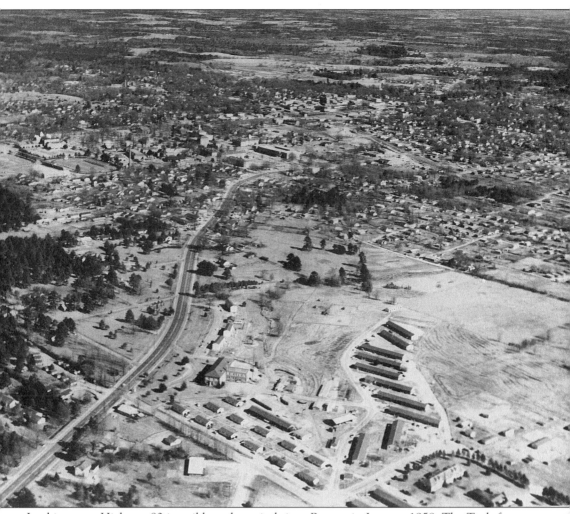

Looking east, Highway 80 is a ribbon that winds into Ruston in January 1958. The Tech farm campus fills the bottom of the photograph. (Woodward.)

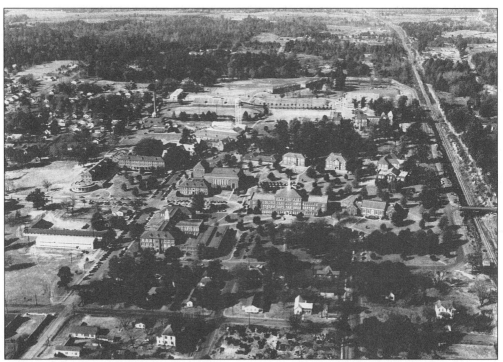

In this 1953 photograph of Louisiana Tech, Keeny Hall is in the center. (Pfister.)

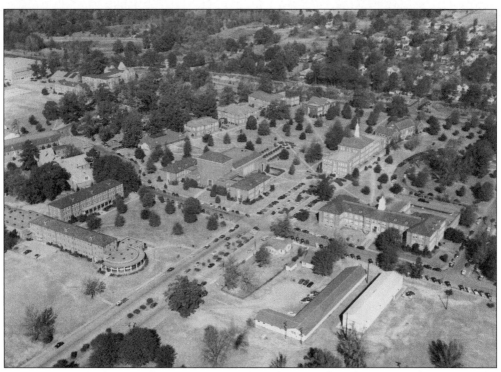

In 1953 we are looking north at Louisiana Tech with Howard Auditorium in the center. The new senior women's dorm, Adams, is in the lower left showing off its circular porch. (Pfister.)

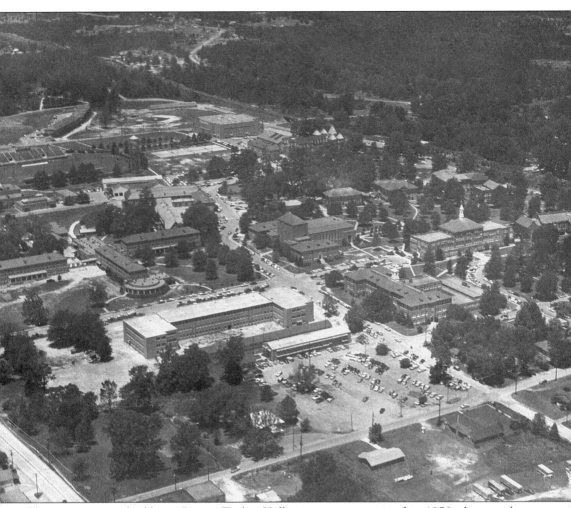

The new science building, Carson-Taylor Hall, is center stage in this 1958 photograph. (Woodward.)

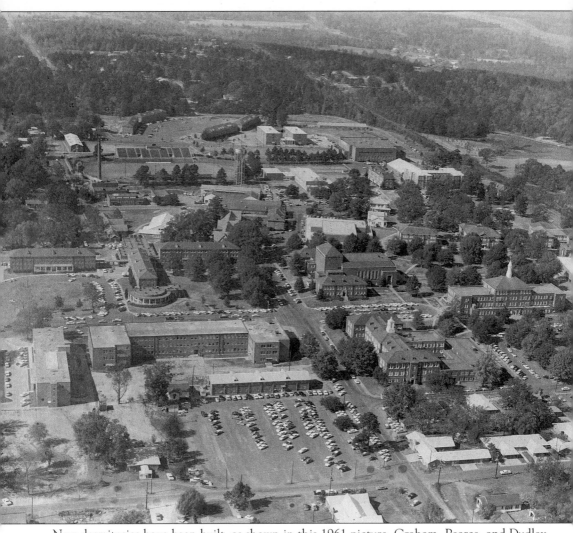

New dormitories have been built, as shown in this 1961 picture. Graham, Pearce, and Dudley are on the left while Mitchell, Jenkins, and McFarland are at the top center. (Woodward.)

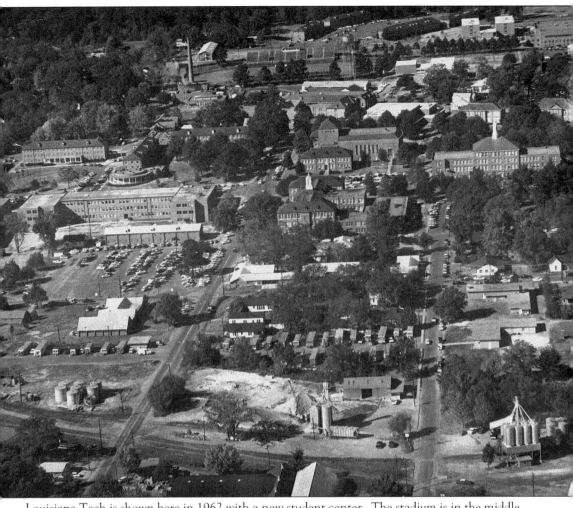

Louisiana Tech is shown here in 1962 with a new student center. The stadium is in the middle of campus, where the A.E. Phillips Laboratory School is today. (Woodward.)

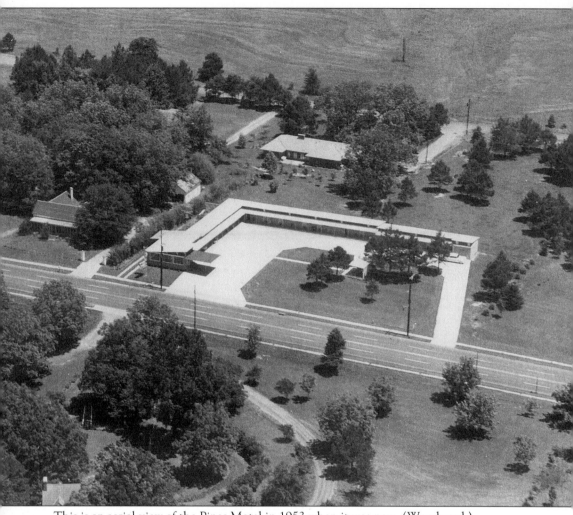

This is an aerial view of the Pines Motel in 1953 when it was new. (Woodward.)